DATE DUE

shooting blind

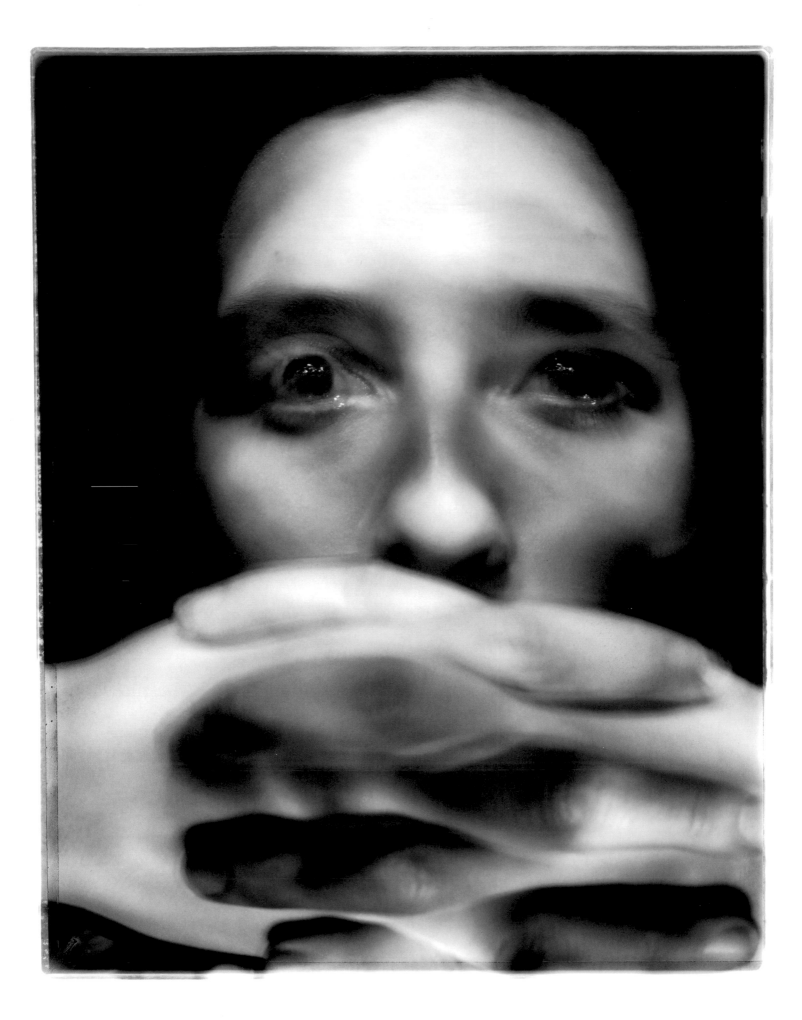

shooting blind

photographs by
the visually impaired

aperture

A PROJECT OF NEW YORK CITY'S SEEING WITH PHOTOGRAPHY COLLECTIVE

2-03-2003
WW
+35⁰⁰

introduction **edward hoagland**

A photographer will ordinarily have sharper vision than the rest of us, besides the marriage of commonality that makes the connection, but here impaired people are trying to help us see more completely, using beams of battery light to augment or subtract body and detail. A crucial part of them has died—is dying—and they may be panicking, plumbing dimensions we skate over, or almost fuguing. *Shooting Blind* is a collaborative project of ambitious intent, using time-lag chronophotography exposures and flashlights in a dark room to sculpt the pictures the photographers want. They're visually handicapped to a considerable degree, but the emphasis of course is on the work. Stamina, tension, imprisonment, humor, and hallucination are frequent themes, yet the element of mourning is often playful, and the collective enterprise is more than therapy. It's "Seeing with Photography," to be precise: the name they have chosen.

A photograph, in freeze-framing a shard of life, may let us see what we ourselves are up to in a new way. The poignance of our ugliness, for example: Not just that we are fitfully ugly, but the reverberations of it, echoing back in memory, and merging with our skeletal, half-throttled, loving hopes—much as ice burns hot and hot is cold. Faces are how most of us measure what life is like (and what I, too, most missed during a three-year period when I was legally blind). So faces are naturally what these semiblind people have focused their cameras on. Flashlight-lit as if X-rayed, the physiognomies are sometimes stripped to their essential and plaintive bones. Life is pared and harrowed, as though for people pinioned in recent bondage—although in profile they seem to aspire still, balancing strain and resignation. Or, on the contrary, the time-lag exposures may add flesh and complexity. No colors; but a milky, precarious wash of light blossoms from the void of black to imply surpluses, whereas before there might have

seemed none. When you need to grope to look, you make the most of what you catch sight of, "mining," as one of the photographers puts it, for imagery that has been confined in the dark, or else cave-painting impressionistically.

The frustration, anguish and rage of going blind has been distilled into some of these pictures, in gargoyle expressions, perhaps, of claustrophobia or mundane fear, or faces nearly erased, or striped, incarcerated, with bands of light like bars. It is bizarre that a human being should be blind, and thus several of the photographers have responded bizarrely, in a kind of energetic cacophony, educating or confronting us, as the case may be, and squeezing from the darkness the mind's eye's preconceptions, its self-concepts. A flashlight can operate as an antenna (or the white cane blind folk use), feeling out locations and emotions, and, like a car's headlights, illuminating what we normally see in quite a different manner. Props have sometimes been added, surreal, or more straightforwardly telling—though at times, I think, superfluously, or there are too many—and at best the effect may become like a scratchboard upon which the flashlights have revealed eloquent, not haphazard, patterns peeled from the blackness. Imagery that appears unmanipulated may have a more compulsive power to arouse our empathy: which this mostly does.

Blindness for me was like a partial death, yet interesting as a process, as death is probably going to be. A negative can throw light on its obverse, and when our time comes, if it is gradual, we will pay close attention to what we're losing in grievous and befuddling sequences that are themselves likely to be revelations: "Oh, *that* is how I ought to have lived!" Hindsight replaces sight when we go blind, and mind and touch and hearing do fill in for part of the loss, as one improvises to try to adjust to the hobbling of both motor and social skills, learn-

ing about timbre, about texture. Life is slimmed and under siege—as is evident in some of these portraits pruned by the flashlight's beam and an overlapping darkness. The photographers' constraints have filtered out a lot of circumstantial ephemera or sophistication. In a bracketed world the wind blows stronger, with special urgency, and we tend to accord the blind more consideration than people who have other handicaps because we can so easily imagine ourselves eventually going blind.

In fact we all are blinded at times. Walking indoors from a sunny day, or stumbling over the dog while en route to the bathroom at night (astonishing *him*, because he can still see), we know for a moment how it feels. Since he has better hearing as well, and forty-fold as many olfactory cells, one might wonder why he isn't the member of the master race, but the puzzle of what-is-life cannot be measured by such yardsticks. That's why we have the arts; and why *Shooting Blind* is not an incongruous contradiction in terms. The question then becomes whether the deck is stacked. Faces—if we take what life has done to them to be significant—can furnish some powerfully intuitive guesses, unless they are all fashion models, for instance, or the proverbial "lowlifes" who grind their axes so intransigently against the grain that they are nearly as aberrant. Metaphorically, we're quite blind to our own motives and other people's sufferings. So, what is the nature of our beast, we want to know, from a painter's or a photographer's vision? And what is spiritual, when we're back to basics, as in several of the ethereal-looking sonograms or excruciating cave paintings, where the flashlight has cut away the fleshly trivia against a black backdrop and faces rise like life forms from a primal soup? Even with no French fries stuffed in our mouths, is this a face God gave the Earth to in the Bible to "subdue" and rule?

That's hardly all we look for in a picture—or when staring at our greedy midriff bulges in the mirror, our wounded, narcissistic, cynical mouths. We are all freaks on occasion, or saintly, and time-lag chronophotography can produce a pentimento effect of ghost imagery or stroboscopic manipulations and after-imaging, and potentially a doubled sadness. Yet I'm most touched by some of the more traditional ones, like *Mary Walling Blackburn* and *Devil Dogs and Vodka, John with Welder's Goggles*, and *Alfredo with Hands Raised*. Also *Karen, Alton, Sara, Portrait of Reed Devlin, Progression, In Sweet Music*, and a number of untitleds or self-portraits. Others appear predisposed to be just scary, prankish, cluttered, almost negligible. A dealer friend has pointed out to me similarities between works here and the photographs of Helmar Lerski, a Swiss who used dramatic directional lighting for head close-ups, or Duane Michals, Arturo Bragaglia, Clarence John Laughlin, Lucas Samaras, Arnulf Rainer, and Man Ray's rayographs and Christian Schad's schadographs. But mainly what we have in hand are glimpses from a supposed netherworld that our terror of going blind ourselves makes a good many of us politely shun, like accounts of chemotherapy. Blindness is not the same as cancer, however. Nor does it really lead to death; rather, to ingenuity. Hooded people devise strategies for the daily necessities of perception, and make sense out of phantasmagoria otherwise. Blindfolded, they are observed in silence by the rest of us. How do you orient yourselves, bear the loneliness, stand the streets? What sort of verisimilitude do you "see" inside your heads, against the wall of your eyelids and skull? And we needn't avert our curiosity and pity or schadenfreude, as we do from people who can look back at us.

These pictures are an outreach, an outcry, a plumb line. They delve with mixed success, but with zest and originality.

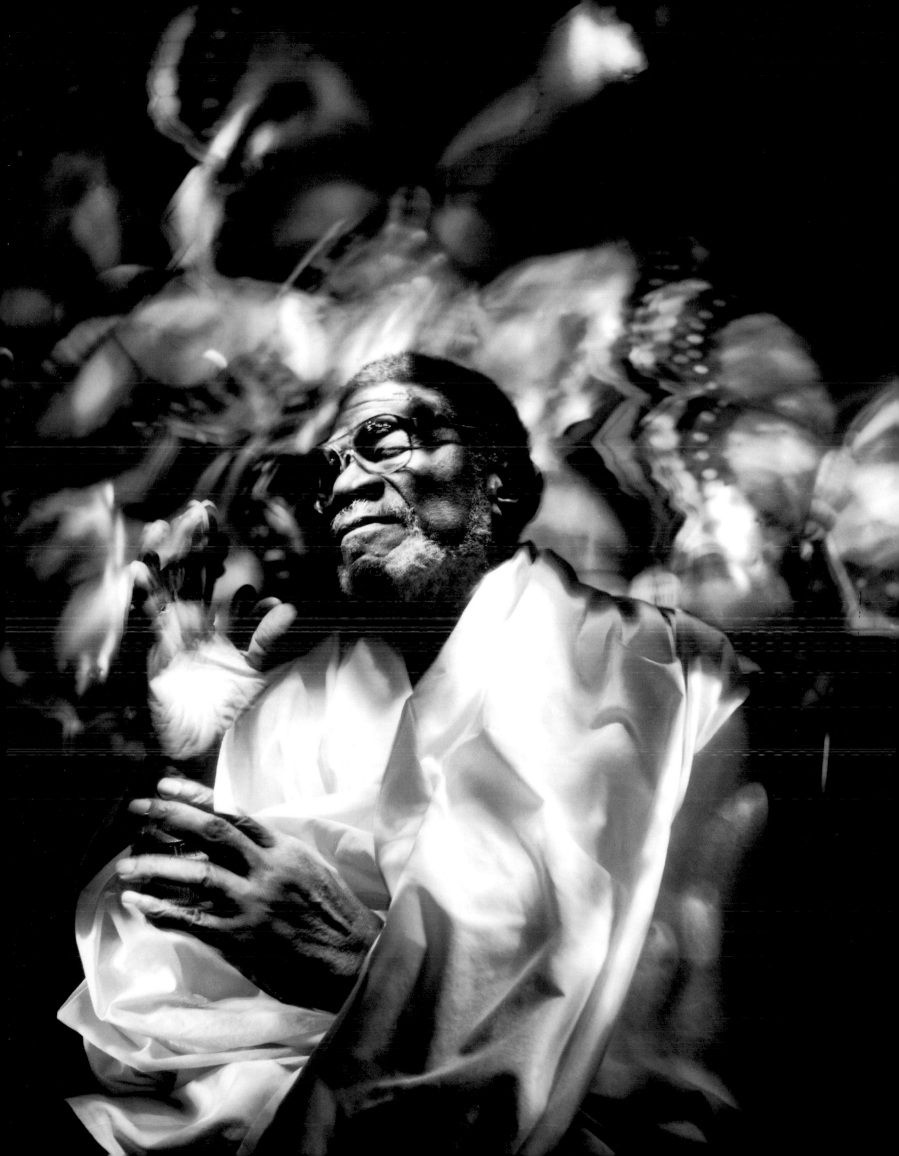

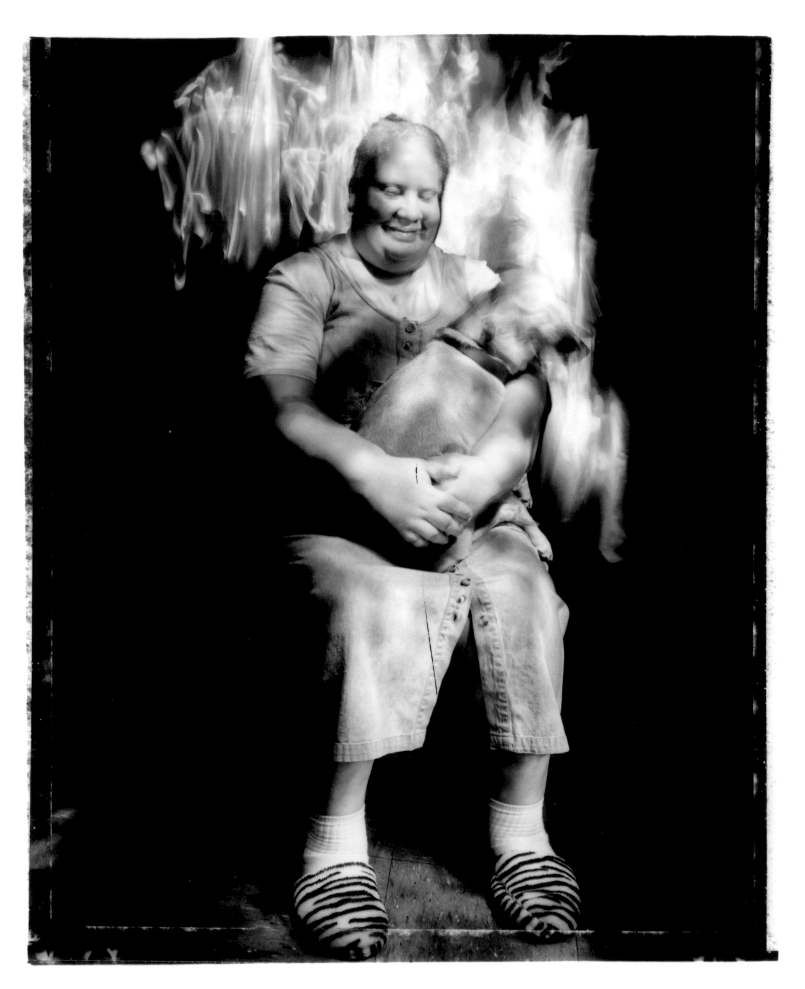

Liz with Her Dog by Steven Erra, Mark Andres, and Peter Lui **10**

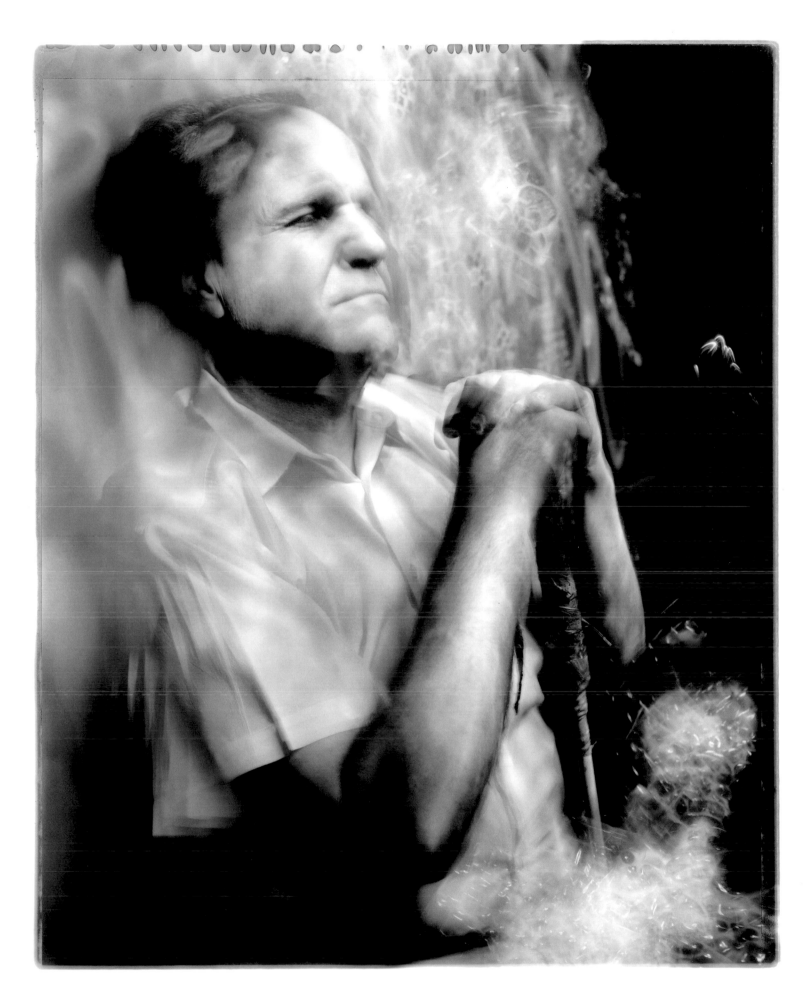

11 *Portrait of Reed Devlin* by Steven Erra

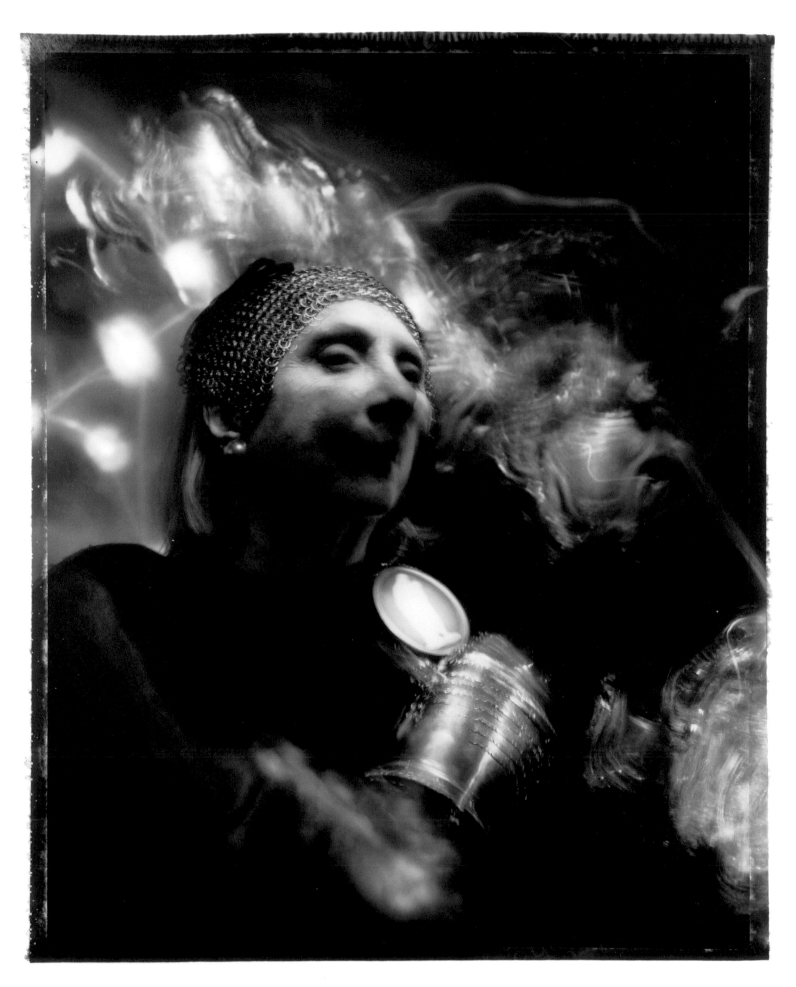

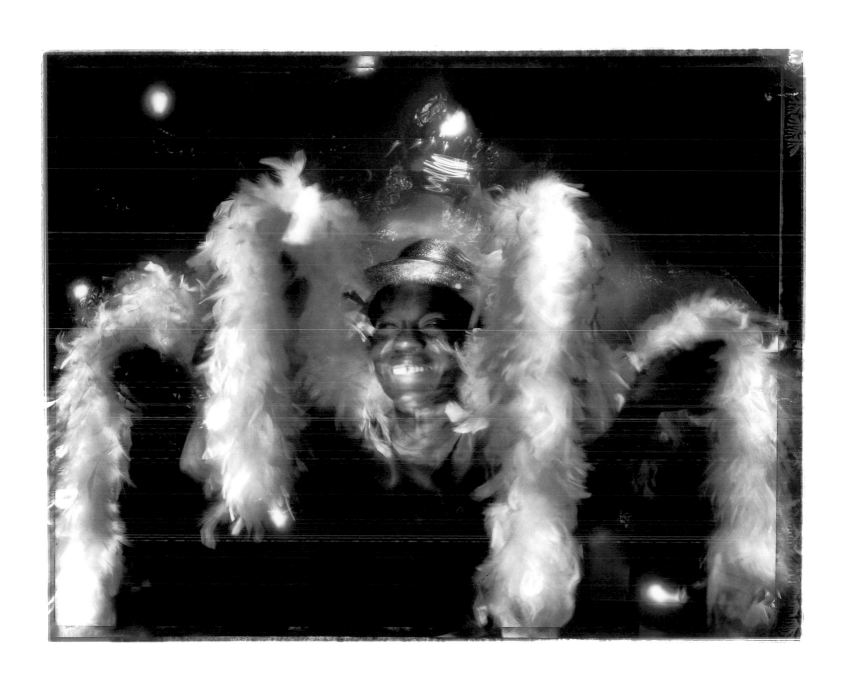

13 *Fun Girl* by Victorine Floyd Fludd with students of the Horace Mann School

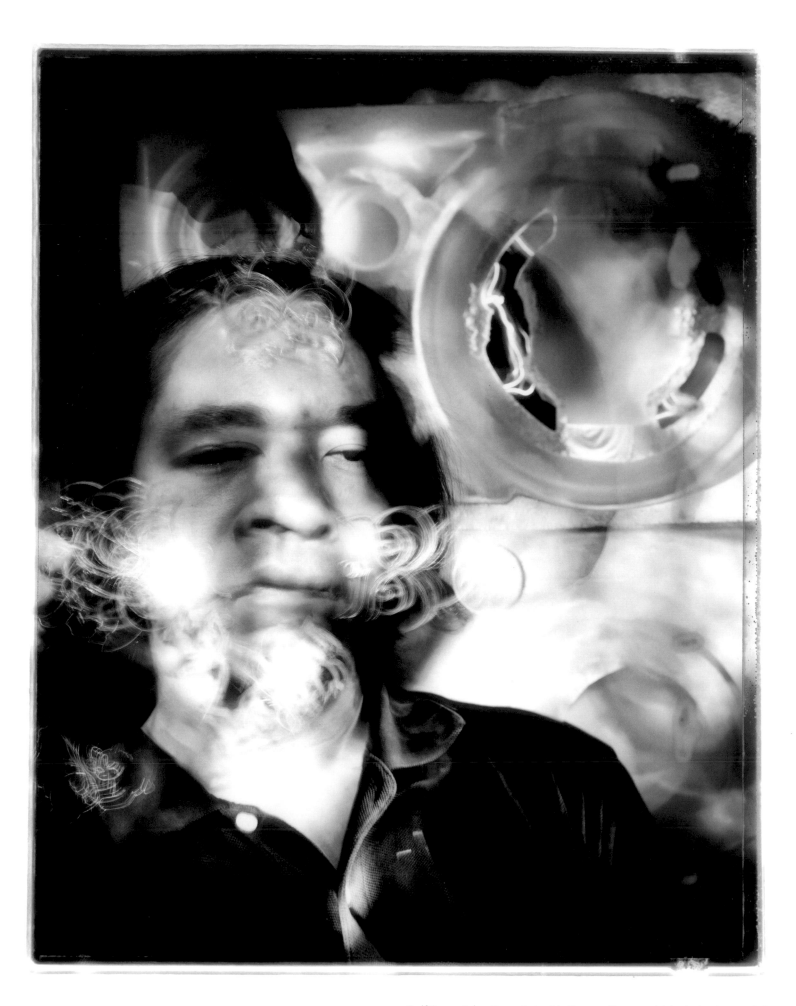

Self-Portrait by Peter Lui with Steven Erra and Mark Andres **14**

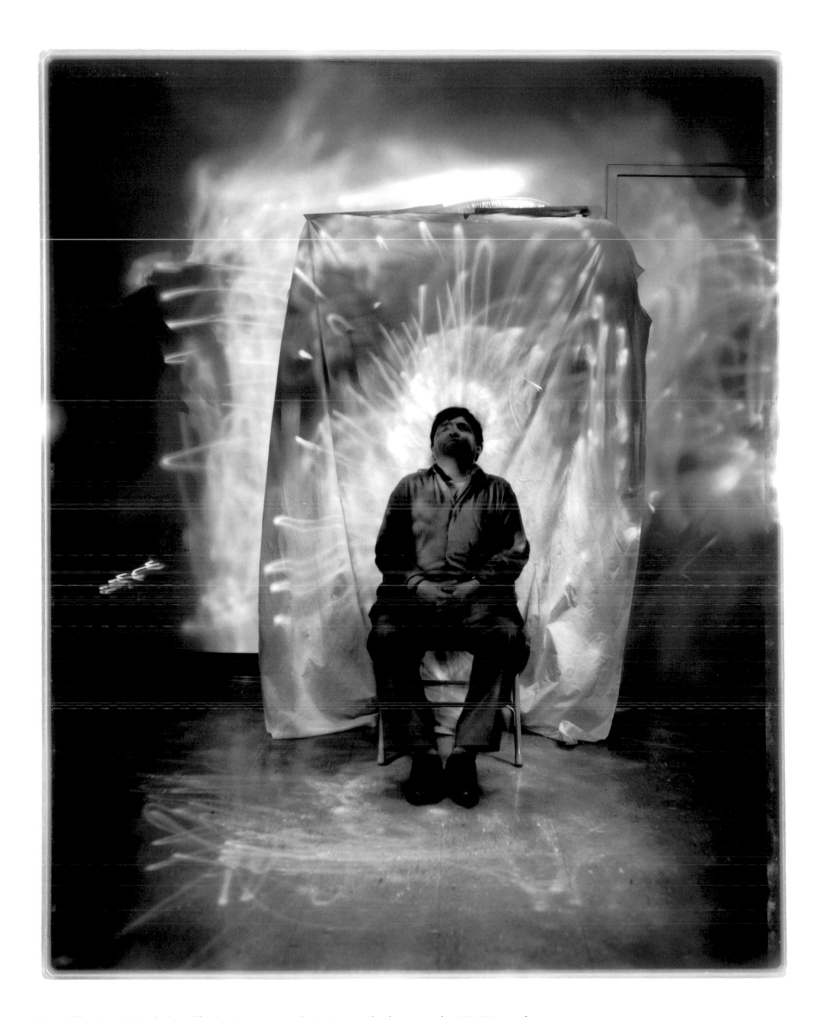

15 *Alfredo with Halo* by Alfredo Quintero with Seeing with Photography (SWP) members

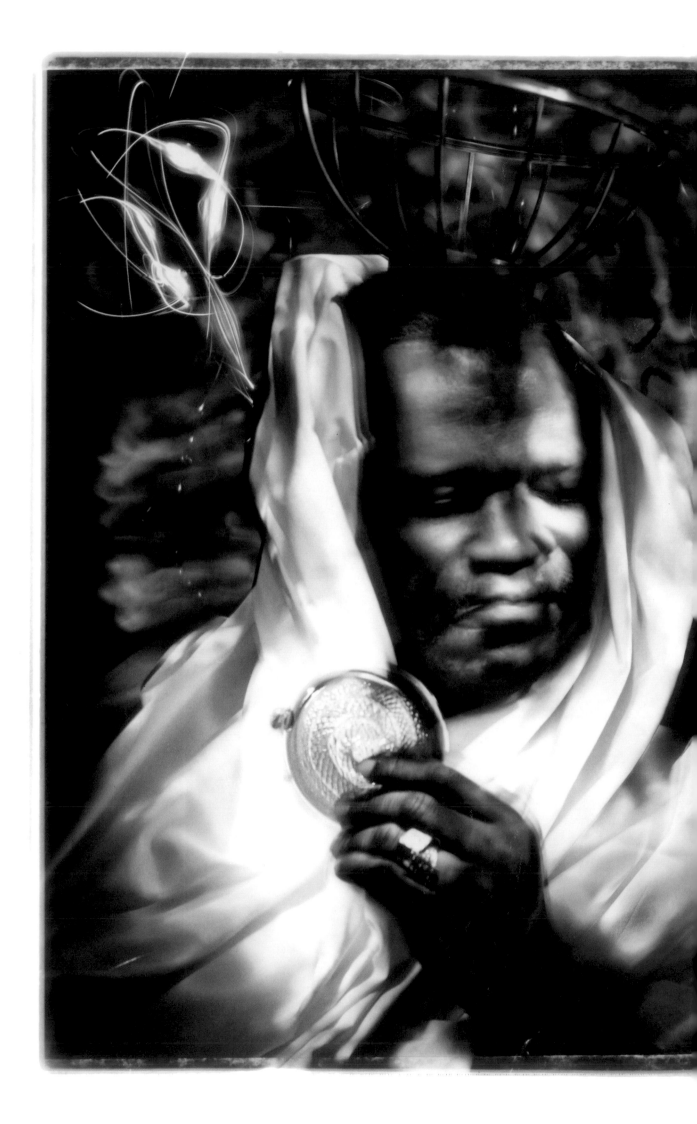

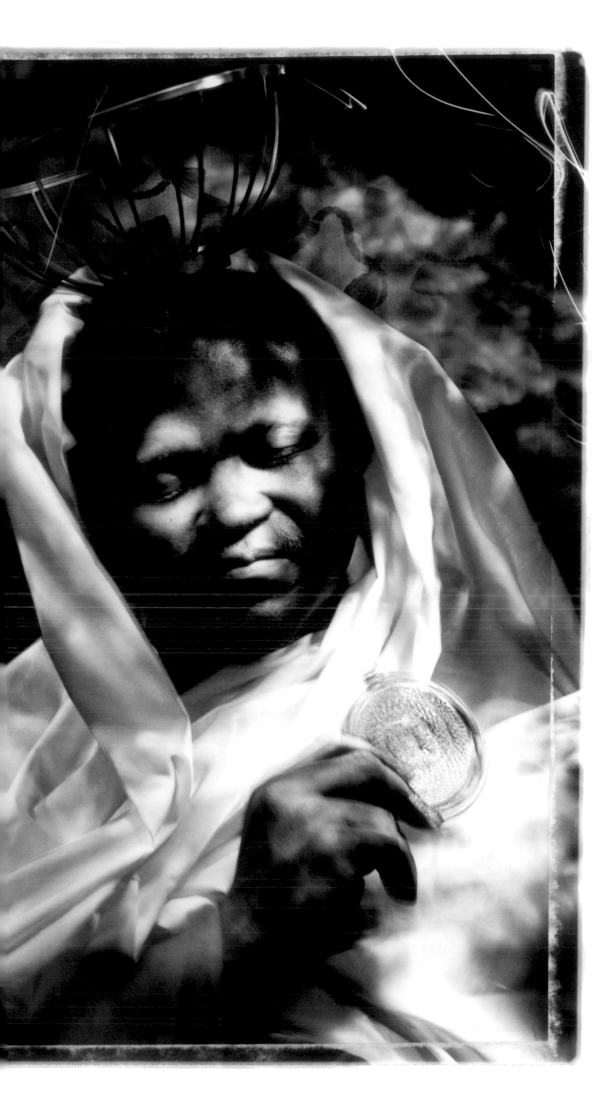

Double Portrait with Glass Medallions by John Gardner, Mark Andres, and Steven Erra

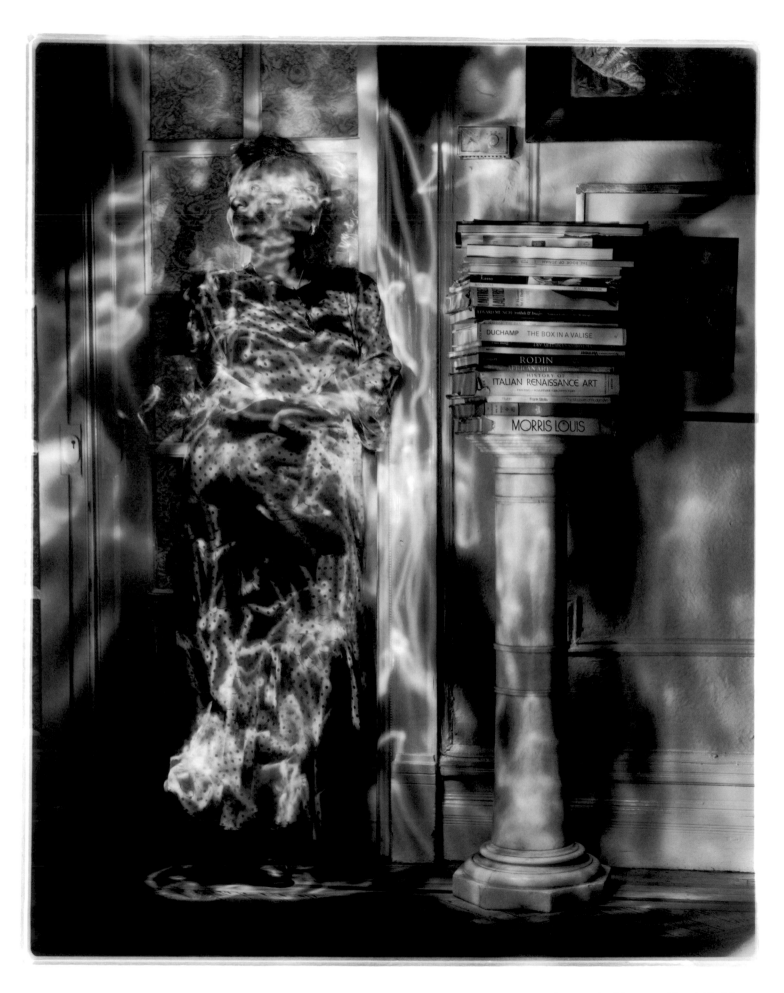

mark andres program director, seeing with photography

Aperture: How did you start working with visually impaired people and photography? **Mark:** It was accidental. A friend of mine originally taught the class at the Lighthouse. She thought I would be a good person for it and that I would be interested. She was right. I immediately enjoyed working with the blind. It made me reevaluate my ideas of photography, teaching, and vision.

How did this project start? **Seeing with Photography evolved from my working with the blind over a long period of time—almost fifteen years beginning with the class at the Lighthouse.** The Lighthouse is a large organization for the blind in New York that had a large arts program. Unfortunately, the woman who ran the program passed away, which affected the organization's commitment to direct services. Since the class needed a new home, I came to Associated Blind and started the Seeing with Photography program. They gave us a basement room. While at the Lighthouse, I was going outside with students to take photographs. In this building, we were printing photographs. I was able to develop a new program allowing me the freedom to work

the way I had always wanted to and develop new formats for working together as a group.

This project was something I had considered for a long time. I wanted us to work in a way that would make photography more a mental and physical process. This way of making pictures seemed to fit the issues and ideas I had been continually confronting in the classes. So we gave it a try; I had been working with the technique on my own as well. It just immediately took off.

Can you describe the technique the group is using? **We are shooting in the dark, using flashlights for illumination, so that the picture is made only where the flashlight is hitting the subject.** There is no image being made in any of the places where the light isn't hitting. The image builds over a period of time—in fragments. Nobody sees the whole image until the Polaroid is opened. It is very different from a normal photographic method where you see what you are going to take. The images are constructed in your head, but also physically. Then they come together, often in very unexpected ways. I could see that this

method of taking pictures was something we could continue to develop, that this was something that could go in so many directions. It couldn't exhaust itself.

How is the class evolving? **In terms of technique, there has been an ongoing process of change.** At first we made really simple pictures. We started out just doing very tight headshots, which are still some of the most powerful images. Since then there has been an evolution of greater and greater complexity. It has evolved in a number of ways. One is in terms of the interaction of people in the class. Another is my relationship to the participants. Some people figured out things for themselves right away, but there were others who in the beginning were very dependent on me for conceptualizing an image. Their dependency lessened as time went on. The group has become more of an ensemble. I'd say that at this point, I have a variety of roles: orchestrator, guide, collaborator, teacher, facilitator, sometimes lead photographer, sometimes simply assistant.

How do you print? **The printing process is the part of our work that depends on what people can physically do.** There are tasks that some people just can't do. For example, they can't focus the enlarger. But they can make a test print; they can set the paper in the easel; they can time the exposure of light. They can do all of that, which can be very satisfying. Sometimes I print and then we talk about what the prints look like.

Describe the process a completely blind person goes through in making these pictures. **They describe what they want in the picture and frame it out for whoever is assisting them.** If people should be in it, the photographers place their subjects as they desire. How deeply the photographer is involved varies greatly from person to person. The way each person approaches the photographs can be very different. For example, Alfredo, who has brain damage, seldom handles the flashlights himself. Rather he describes explicitly certain rules we must follow. He takes pictures of himself. He tells us exactly what he wants. It is important to Vicki to light herself. Peter has a strong basic idea, and then works collaboratively. Steve Erra often sketches his ideas in advance of shooting.

Are there recurring concepts? **Different people return to different themes.**

Morty King always seems to do pictures about freedom. Most of his photos have a feeling of flying. Stephen Dominguez always confines his subjects—wraps them up, ties them up, or puts them in closets and in small spaces. They're always closed in. Vicki has been doing a lot of portraits where she is fragmented in many different ways. The pictures are getting very elaborate. I think of them as getting more baroque as we've worked.

In what direction is the collective heading? **I think we are ready to branch out of this room.** That will make a change in terms of what happens with the work. One of the things that is great with this technique is that you can use anything—it's not object dependent. Nor is it dependent on physical surroundings; we can make photographs anywhere. The images come out of people's minds and aren't heavily dependent on the environment. We have been working more and more collaboratively since we began. I think it would be interesting to collaborate with more people from outside our group, whatever their visual acuity.

Who would you like the collective to work with? **It could be almost anybody.**

It would be really interesting to work with an artist or someone who has a good understanding of working with people and doesn't necessarily have a background in the arts. One of the incredible things about this project is that you can work with a variety of people. There is a freedom to contribute with this method that is quite wonderful. A blind member's aide, a professional photographer, one of our children—almost anyone can make an immediate contribution to the work.

If the collective comes to an end, do you think people will continue making photos on their own? **Yes, some definitely would.** But I hope we are going to grow rather than come to an end. I really wish we would continue to grow. There is something truly important missing in New York in terms of the arts programs for the blind. Perhaps we can be part of something that would improve that situation. There is a need for more programs that directly involve people in the arts. Unfortunately, they really are not funded, as often happens with the arts. These programs are the first to get eliminated.

interview with **arthur krieck**

Arthur: I started in the photography class when Mark was teaching at the Lighthouse in 1989. My father was on the rehabilitation staff. As a partially-sighted young man he recalled that if he took pictures of things, he could see them more easily. He recommended I take this class.

I have never been fully sighted. I was totally blind until I was one and have been partially sighted the rest of my young adulthood. I lost a great deal of my sight in my thirties, which is typical of my condition. It [deterioration] has been progressing since, but is still relatively stable.

What is your condition? **I have glaucoma and congenital cataracts.** I lost one eye when I was twelve. My vision has been up and down my entire life. I grew up as a partially-sighted kid. My parents had no vision at all. I was part of that world for a long time. I was a very visual child, as well as being very musical. I was always taking drawing and painting classes. I started taking pictures when I was eight years old, when I got my first camera. I got another camera at fifteen, a Polaroid camera at sixteen, and my first SLR at eighteen. I still have all the negatives from when I was seventeen.

Did you describe the photographs to your family? **By that time, my family and I were very disconnected because I wasn't quite the person they wanted me to be.** I stopped talking to them. [This was] probably because I was a gay kid and that wasn't acceptable. So I drew, painted, and practiced my violin. Then I got into Music and Art High School, which really changed my life. I played professionally for a long time. I went to a conservatory.

How did you get back into photography? **I never stopped!** I was always interested and read about it. As I became older, I determined that I still needed that visual creativity. I started working with Mark and I loved it. He's very painterly and he brings a fine artist's sensibility to photography, which I really like.

It was very interesting for me to start connecting with the blind world again. I had been around it all my life with my parents but I tried to pass as fully sighted for a long time and I didn't want anything to do with it.

What I really want is to take pictures the way I see things because I see in a very distorted way. I can see your face very clearly, but everything around you is just shadows and shapes. Essentially, I only see what's straight ahead and everything else is crooked. It's a very odd way of seeing, but I've gotten used to it. If it's moving it's a blur. I don't know how to technically create that effect in photographs yet. I might be able to do it digitally and that's something I haven't yet explored.

Do you see things in layers, like paintings? **Pieces, I see things in pieces.** When I bring them up in memory they are not in pieces. It's as if I can see things normally. Somehow my brain puts it all together. Looking at a building, my eyes can only see part of it at a time. I move my eyes around until I see the whole thing. In memory I can see the whole thing. The brain is quite remarkable isn't it?

Why create a photo to show how you see? **I think it's for the same reason any artist creates—to show your point of view.** The more points of view that you see, the more you can understand reality.

How do you feel about the flashlight technique you are using right now? **I had my problems with it in the beginning and didn't really get where it was going.** I've been in this collective since the beginning and have seen the process evolve over the last couple of years. Now I can see what Mark is after. It really does allow a certain kind of photography that's not possible any other way. I think he really wants the unconscious to be expressed and he sees this [technique] as a way of allowing that to happen. It shows a process rather than one instant. In that way, it's more like daguerreotypes, like early photography, in that the exposures were so long.

Who is your audience and is it necessary for them to know you are visually impaired? **That's a tough thing to talk about.** As a musician I don't make an issue out of it. Although I'm still working, I am aware that some people won't hire me, not because I can't do the work, but because they *think* that I can't do the work.

This book is not for people who are visually impaired. I think it's for visually-impaired people to become more visible and to connect with the fully-sighted audience. It's for a sighted audience to realize that we have something to say, too.

The most intriguing thing the collective has found is the correlation that if something sounds interesting, it is interesting. It's the totally blind photographers that take the most interesting pictures! John's pictures are fabulous because he's totally uninhibited! He has very low light perception—that's about all he has. We all have these ideas about how something should look and this frees us creatively. Alfredo, apparently, is the same way. His mental disability frees him up, so he can express himself in a totally uninhibited way that somebody else might not understand, but he understands.

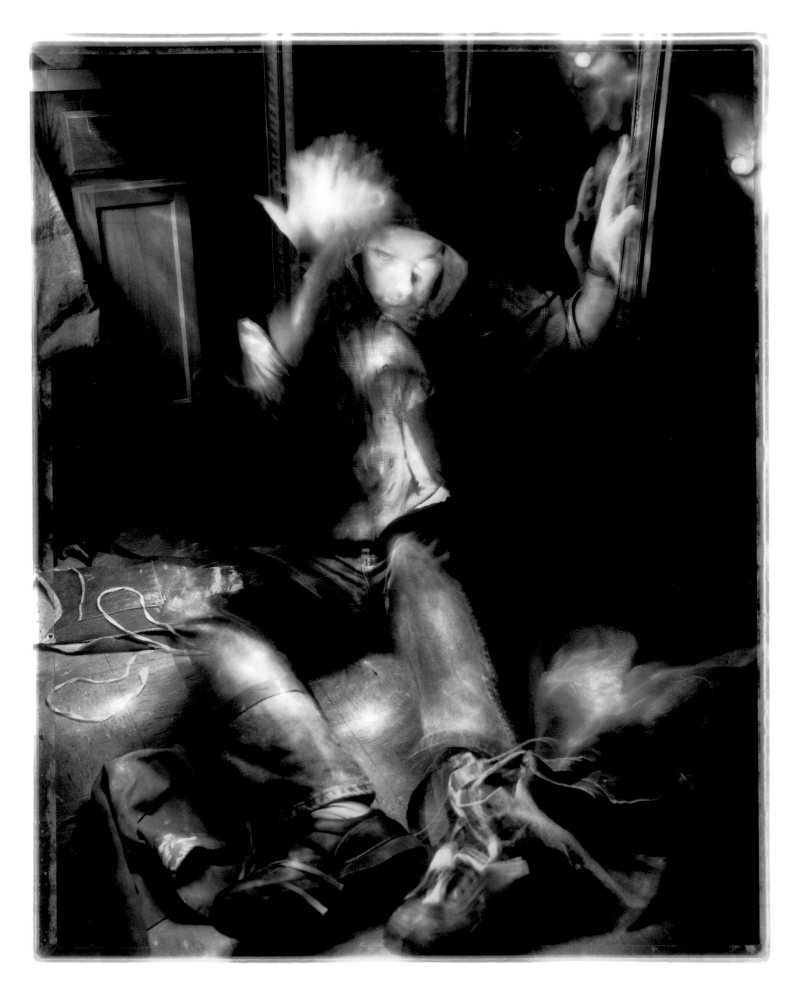

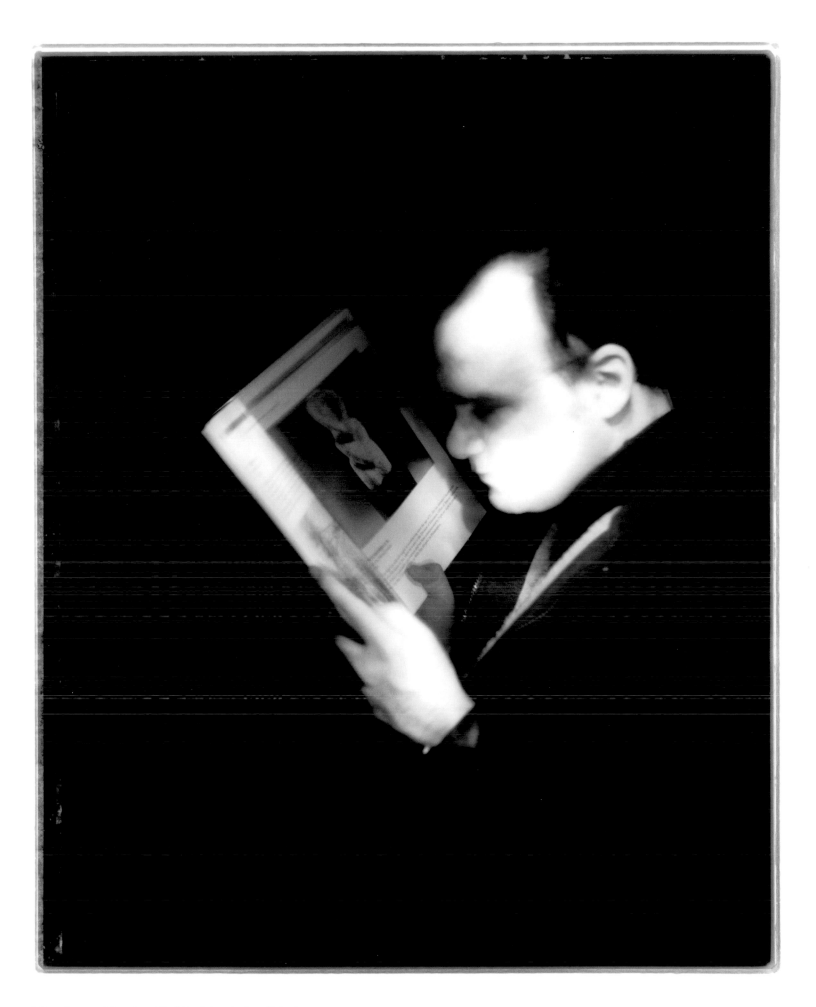

25 *Steven Viewing His Work* by Arthur Krieck

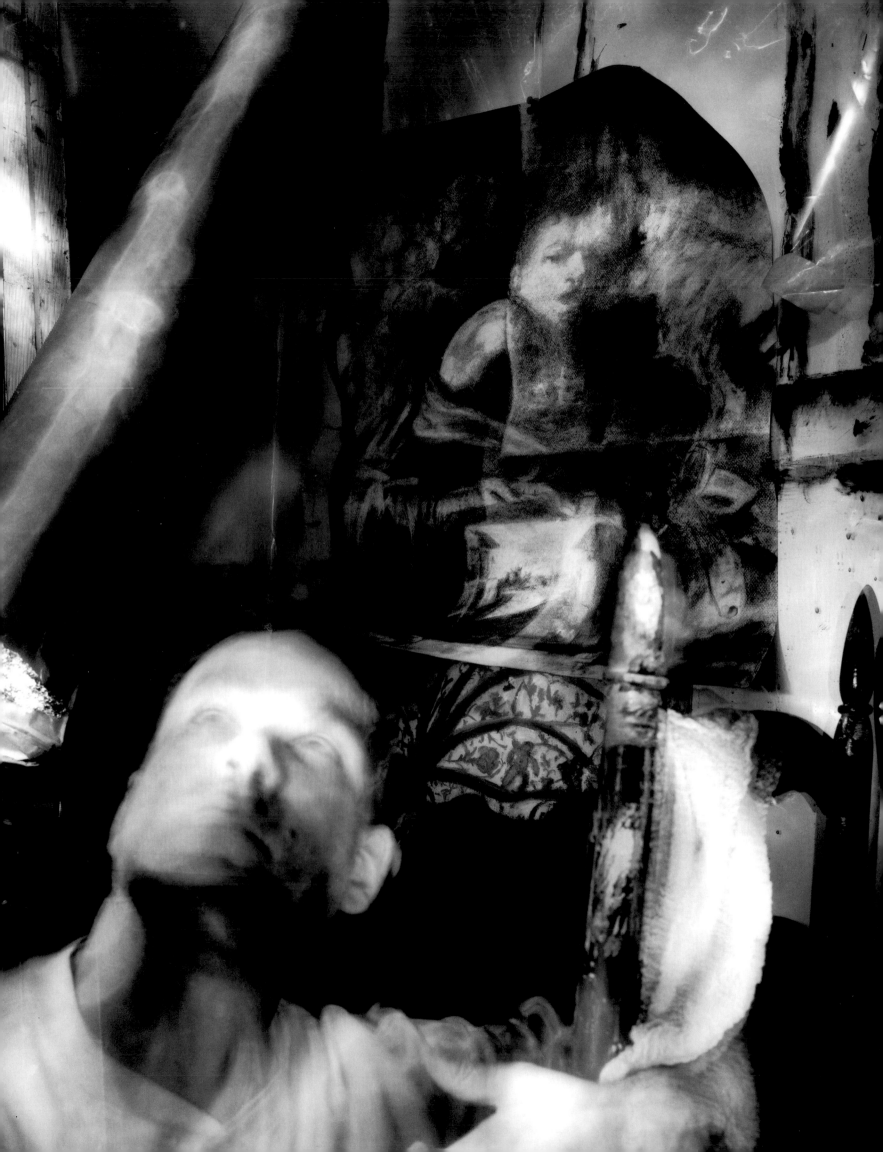

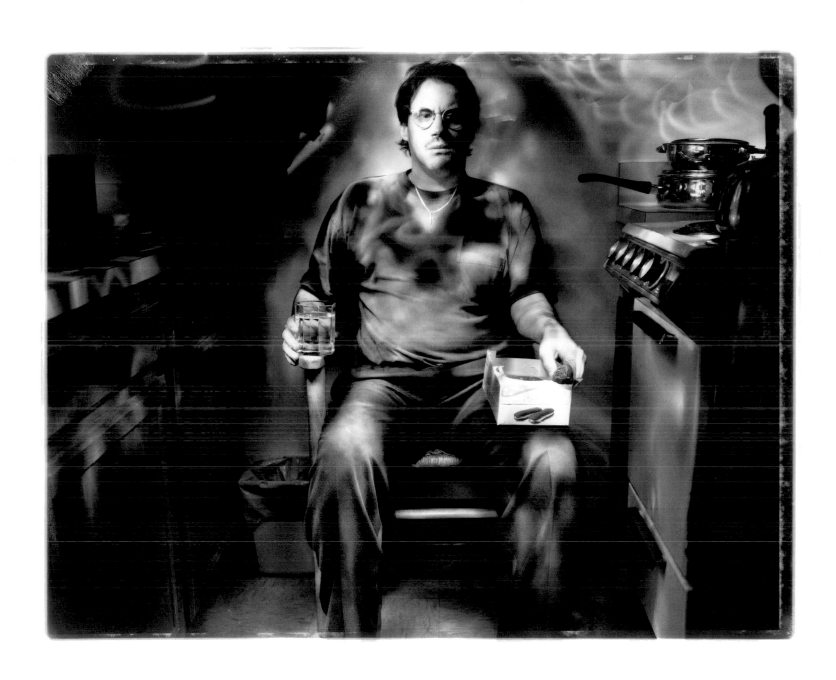

27 left: *Niépce* by Steven Erra above: *Devil Dogs and Vodka* by Stephen Dominguez

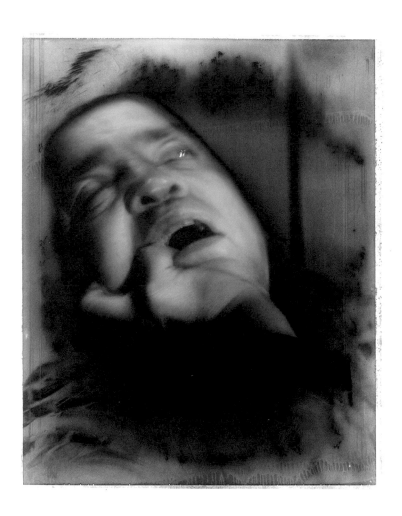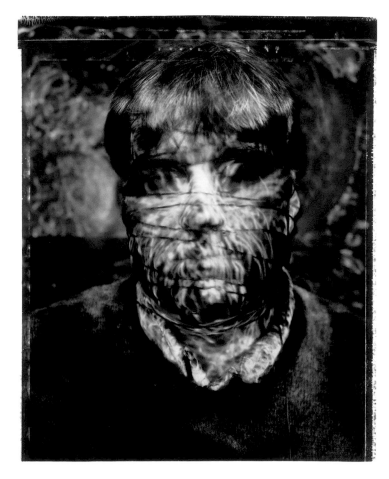

left to right: *Tormented* by Peter Lui; *In Someone Else's Shoes* by Stephen Dominguez **28**

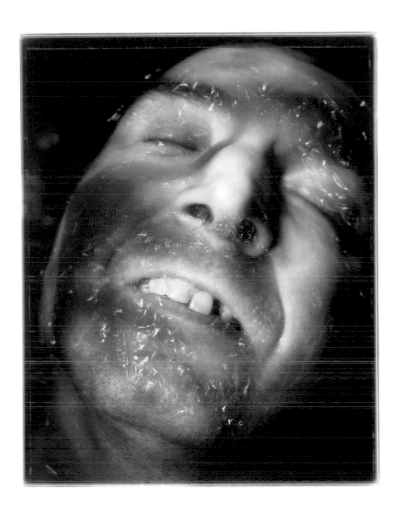 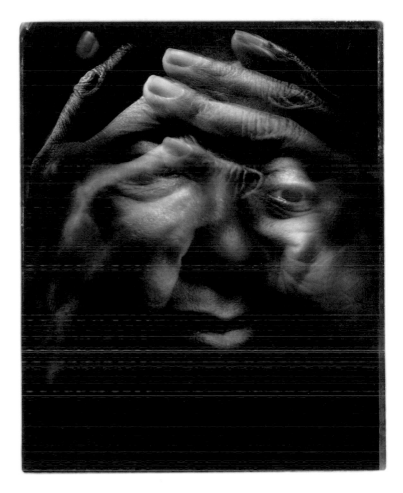

29 left to right: *Poem of Ecstasy* by Stephen Dominguez; *Portrait of Doug* by Doug Ford and Mark Andres

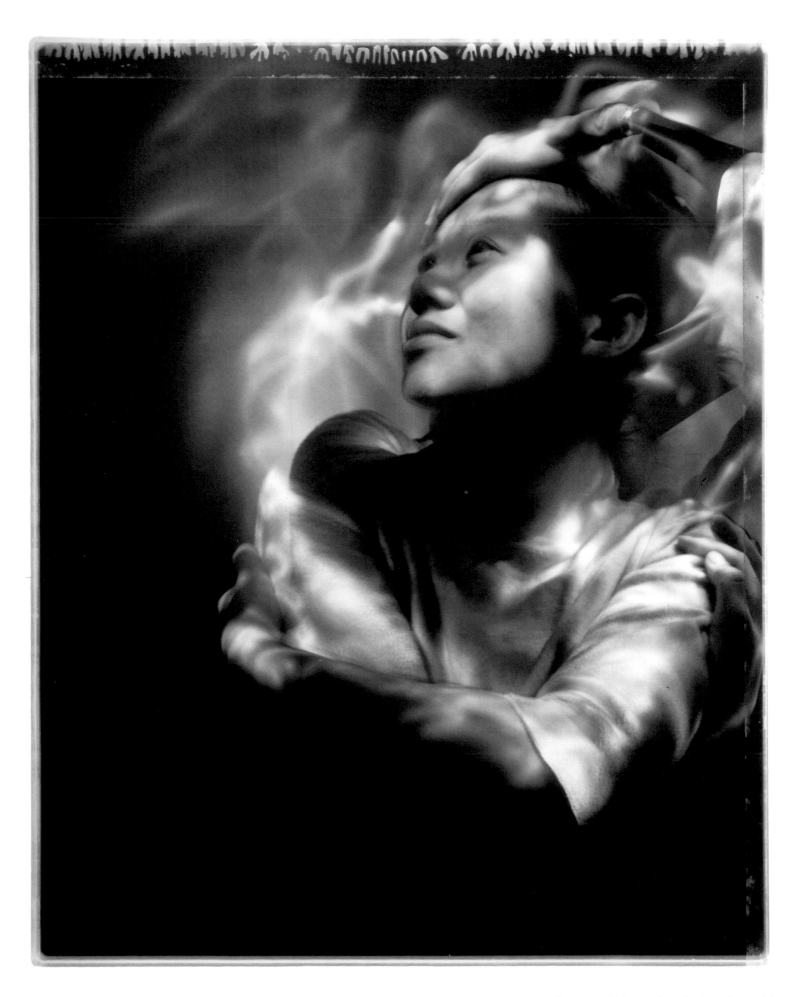

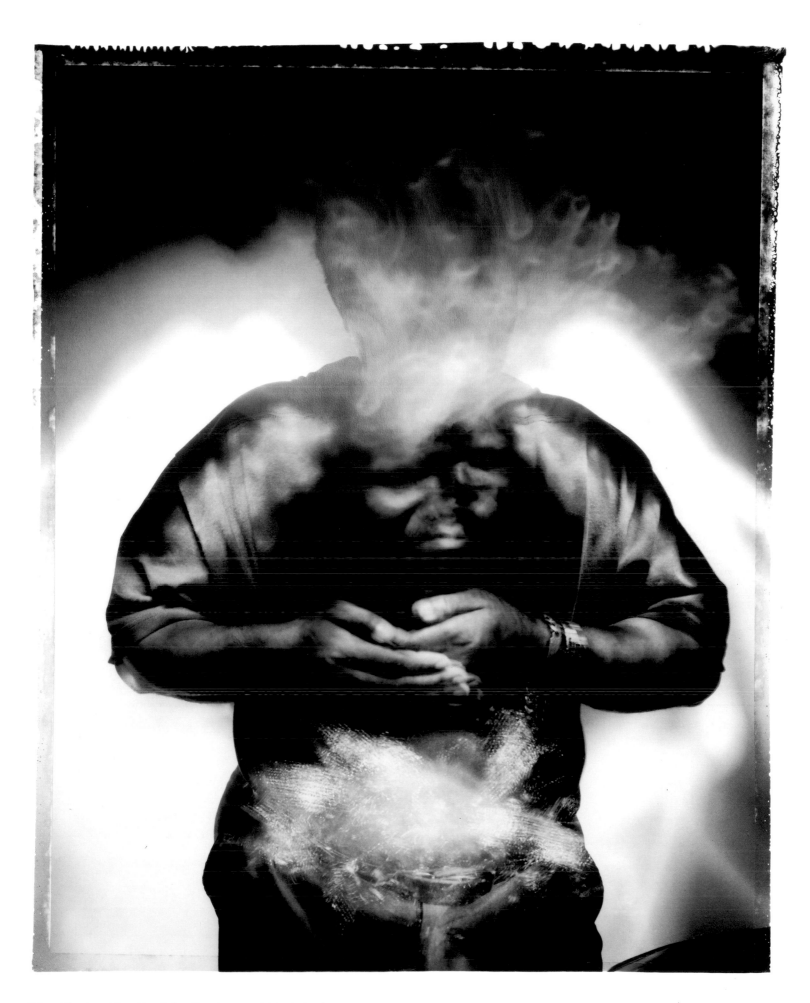

The Lost Head by John Gardner and Mark Andres

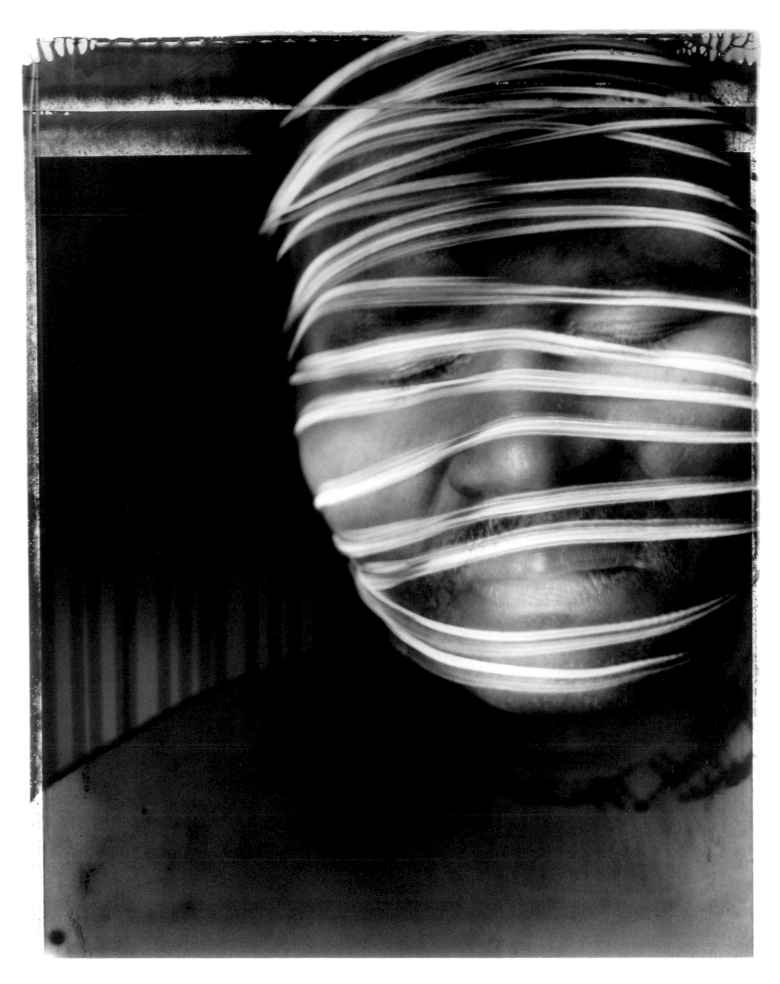

interview with **stephen dominguez**

Stephen: I was born in New York and have lived in Brooklyn all my life. When I was younger, my brother was an artist and I also wanted to be an artist. Later on, when I developed a visual impairment, I was discouraged from pursuing visual art. So I studied music instead. In 1986, I started taking educational classes at the Lighthouse. One of them was a photography class and that's when I met Mark.

How has the collective evolved over the years? **Everybody is a little different.** Some people see more than others, some people don't see at all. Mark works differently with everybody. For a while we were just mainly in the darkroom.

Is it difficult to use the darkroom? **There are some problems with focusing the enlarger, but you can get someone to help you with that part, the alignment.** Walking around the darkroom, that's nothing!

What exactly is your eye condition? **I have glaucoma and cataracts. Of all the people here, I may see the most out of all of them.** I don't see the detail. I don't see the small things. I don't have vision in my right eye and my field of view is small. Glaucoma destroys the vision, peripheral vision. My eyesight has been stable for a long time.

How does it become stable? **I don't think doctors know.** For as many people as I've met, I don't know one other person whose sight has not gotten worse over the last ten years. Most of the people I know used to see like I did, and now most of them are totally blind, but I haven't [gone blind]. I attribute it to holistic medicine.

There are two different types of glaucoma: one where you have terrible pain, and one where you have no pain. I have the one where there is a lot of pain. When the pressure went up, I could feel it and it wasn't good.

My brother is blind. Two of my sisters are blind. Glaucoma is congenital. They are older than I am. I saw what happened to them. They started out like me and now they are totally blind or nearly blind. They've had operations that didn't help and they've taken medicine that only helped for a little while and all the time you suffer.

Some people in the group are making images that have to do with their conditions. Is that a theme for you? **No, that's not what photography is about for me.** It's about engaging in a process that is creative. I think that overrides the rest of that. I don't want to lock myself into a category. It's limiting.

Who is your audience for these pictures? **People who like photography.** Beethoven was deaf, but he still created magnificent work. His handicap wasn't an obstacle.

It's very individual. I can't tell people to like what we're doing. I do it because I like it. I'm not going to force you to look at it.

Have you been able to go as far as you wanted to with your work? **No, I haven't.** But right now I have no time. My time is being used in a different way. I am studying occupational therapy in school and it takes me longer than everybody else to get things done. It's a lot of work.

What do you think the collective expects to get out of this project? **I think it's different for everyone.** We'd like for people to not look at our handicaps. Even the people who want to talk about it, it's a way for them to heal themselves.

They want to show people that they're human and that having a handicap is not necessarily a bad thing. It's an inconvenience but not a bad thing. It's a bad thing if people are going to discriminate against you. People here want to show that they can make something nice.

Do you play music now, and if so what instrument do you play? **I play trumpet, flute, saxophone, clarinet, guitar. . . .** People say why don't you play one, don't you have a favorite one? I say, well they are all colors. By themselves they represent their own colors and not only that, you interact differently with each instrument. They have a different feel and handle, different ways you speak through it.

Mark is like a conductor. We are a group and we work together. Mark lets everyone find what's best for them and where they're going to take it. We are mining for something as a group and as individuals.

interview with **esmin chen**

Esmin: I'm from Jamaica, the West Indies, and I have been in New York for twenty years.

Why did you join the collective? **Seeing everybody work.** I thought, I could do this, too. If they can do it, I can do it.

They inspired you. **Yes.**

What kind of pictures do you want to take? **Sometimes I take pictures of relatives.**

Do you imagine what you will make before you go to the collective? **I'm just hoping it will come out.** I just go and take a picture and hope it will come out.

What can you see from two feet away? **I see that your arms are folded.** I think I see you clearly. I see the pictures around us but I can't see what they are of. Sometimes I look at something that is purple and it looks blue.

My eye disease is optima dystrophy. It's a nerve in the back [of the eye] that is damaged. I had my sight when I was growing up. At eighteen, all of a sudden, I discovered I couldn't see. My vision was worse then than it is now. But gradually it improved. I came to the U.S. after it started getting better.

When people look at your work, would you prefer them to know you are visually impaired? **Yes.**

Why? **I want them to know that blind people can do things, too.** Some people don't know that blind people can do different things.

Who is your audience for this book? **Sighted people.** So they can know what blind people can do. So they can really see, because some people think that the blind can't do anything! It's not late, according to the old Jamaican saying. It's not too late for a shower of rain. If you like it, you get into it and you start doing it 1, 2, 3!

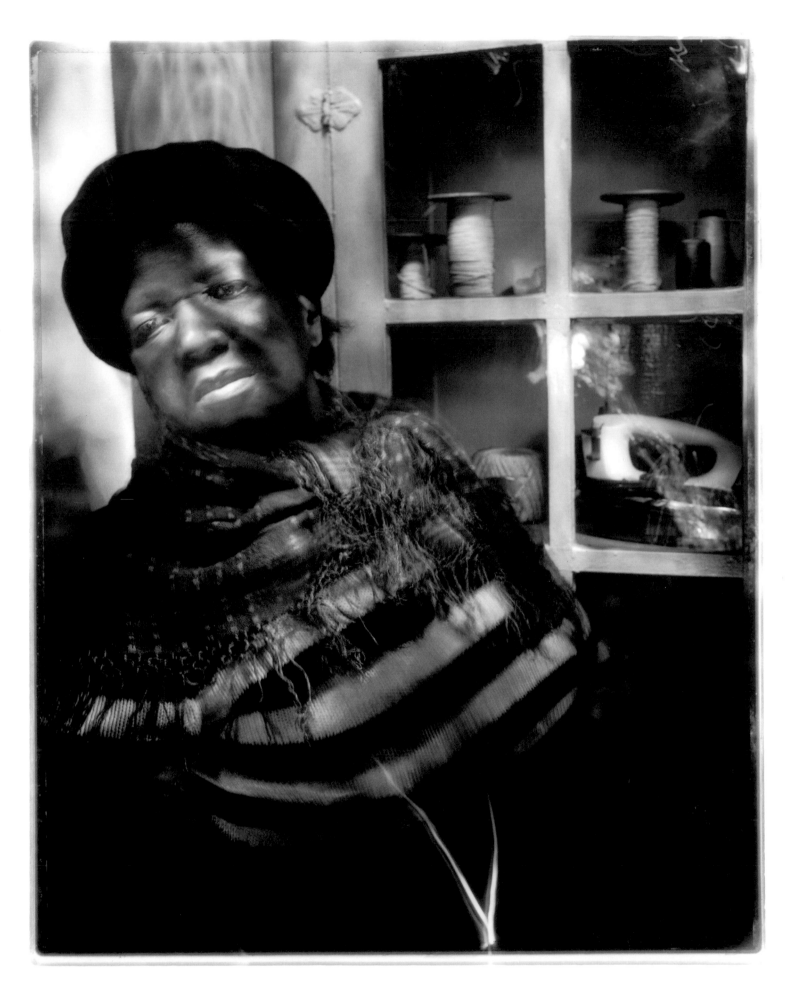

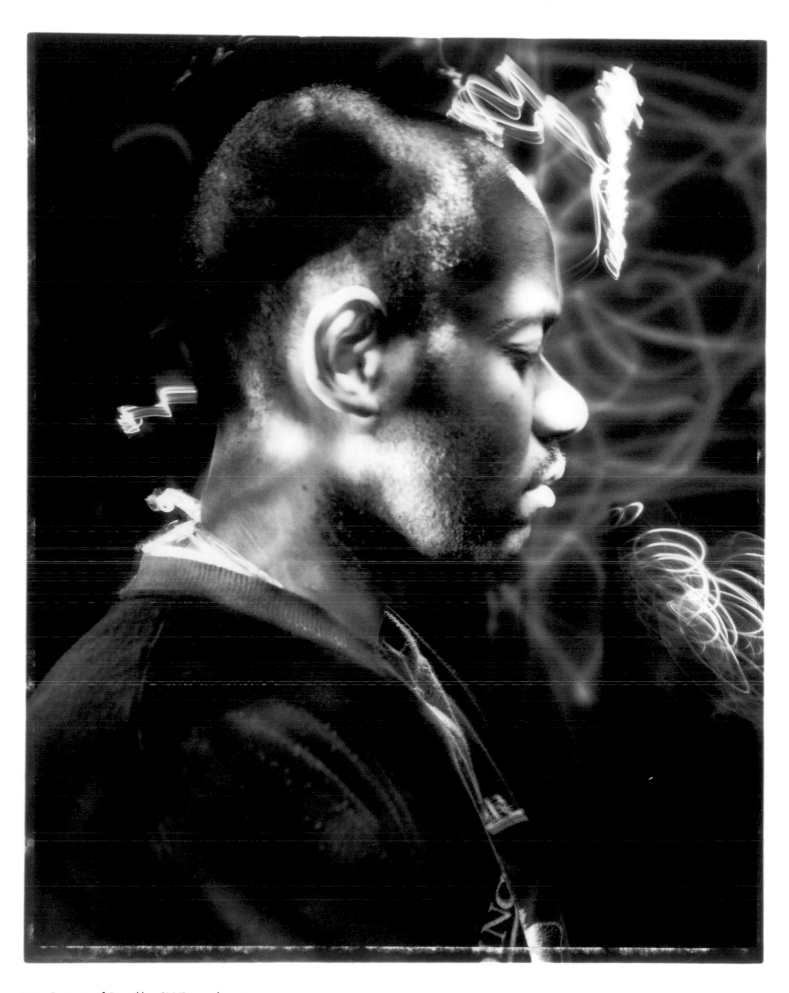

37 *Portrait of Daryl* by SWP members

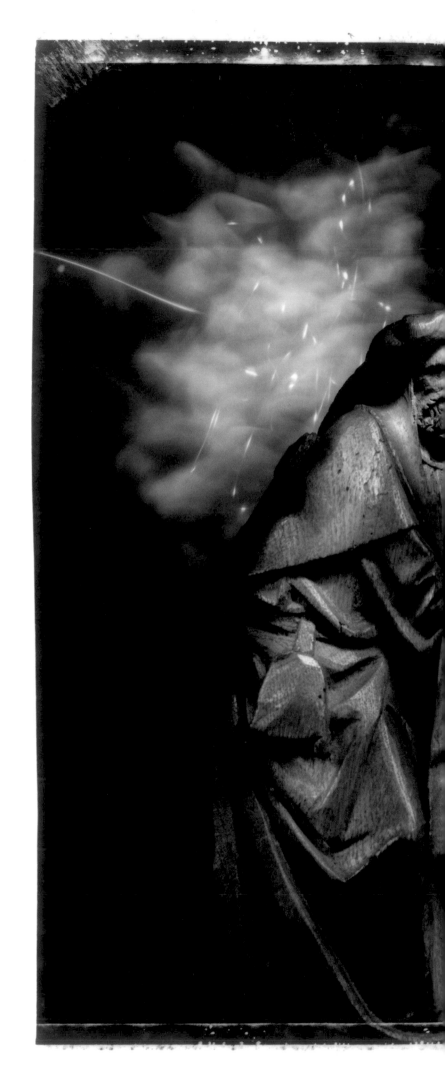

John with a Statue of Christ
by John Gardner and Mark Andres

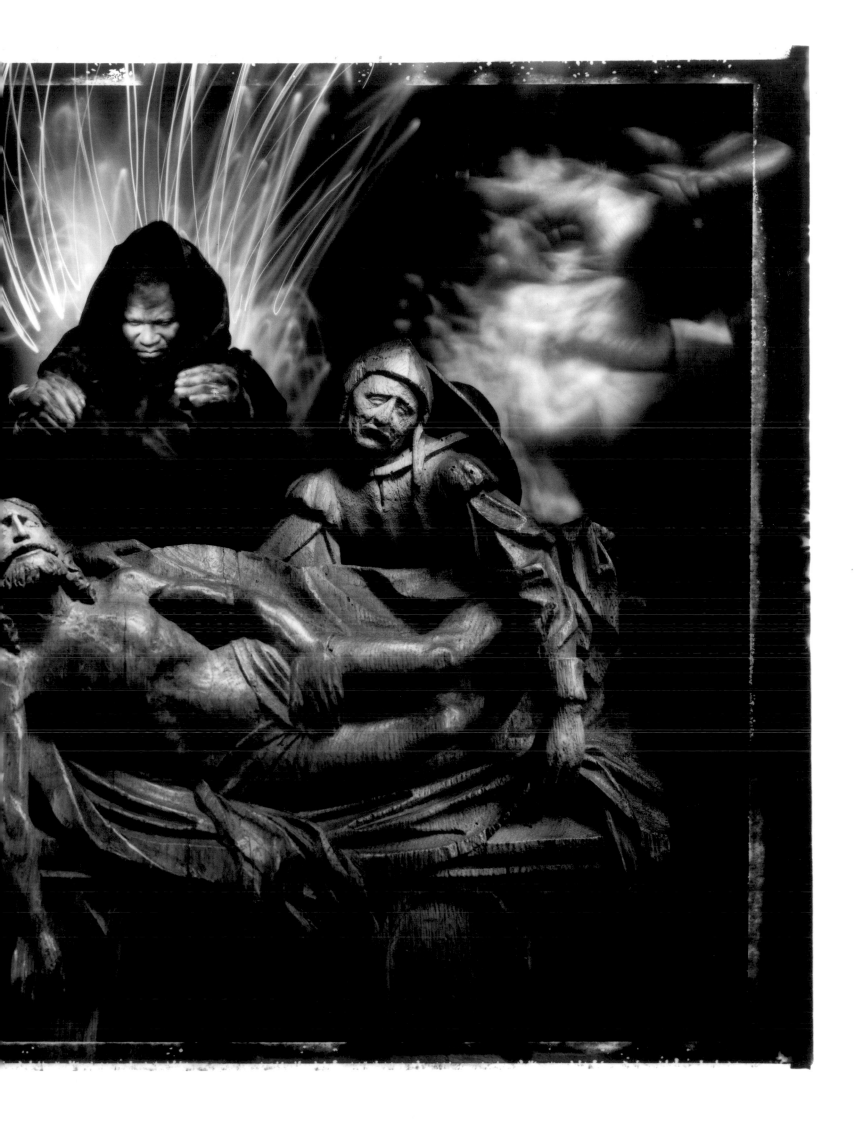

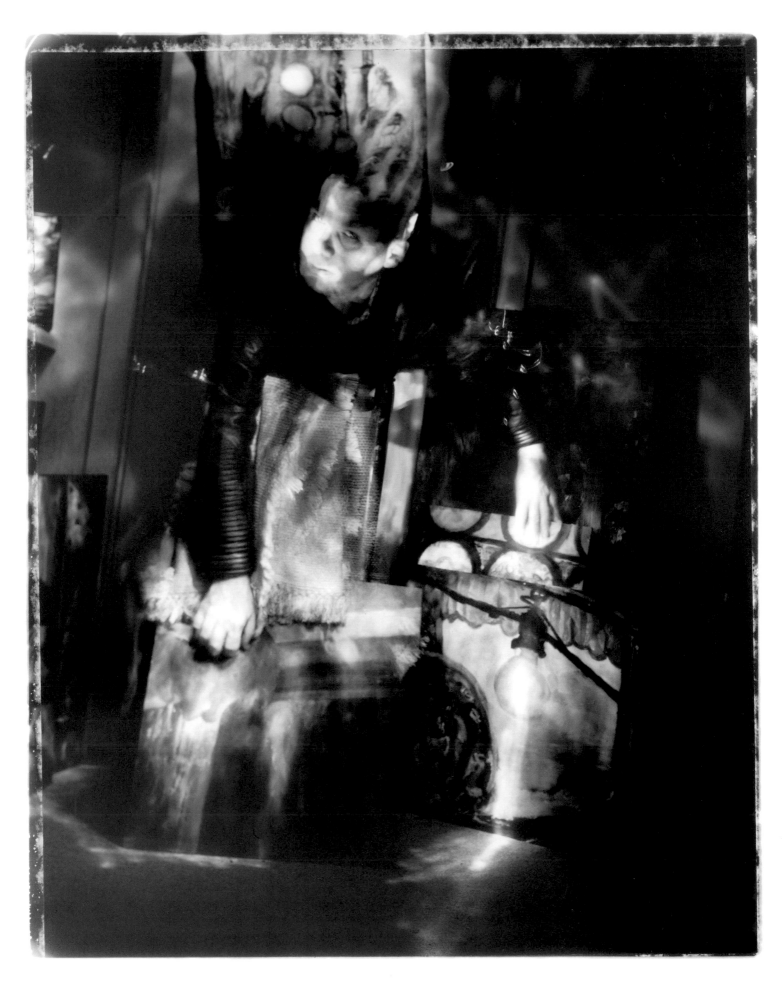

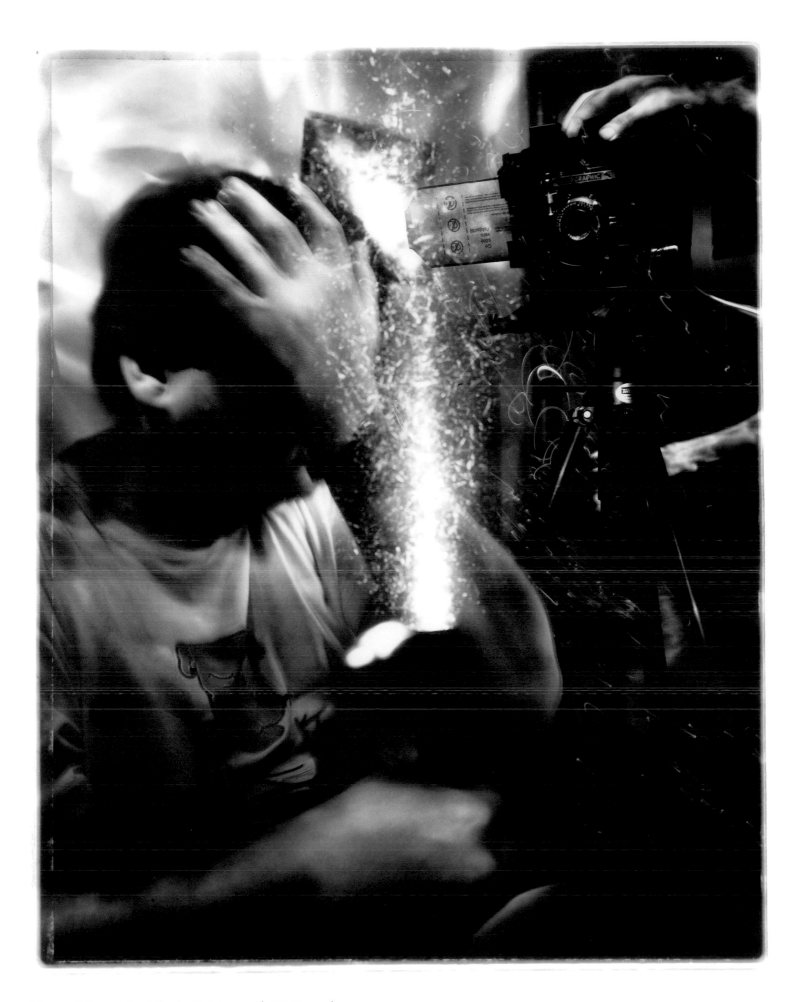

41 *Self-Portrait* by Alfredo Quintero with SWP members

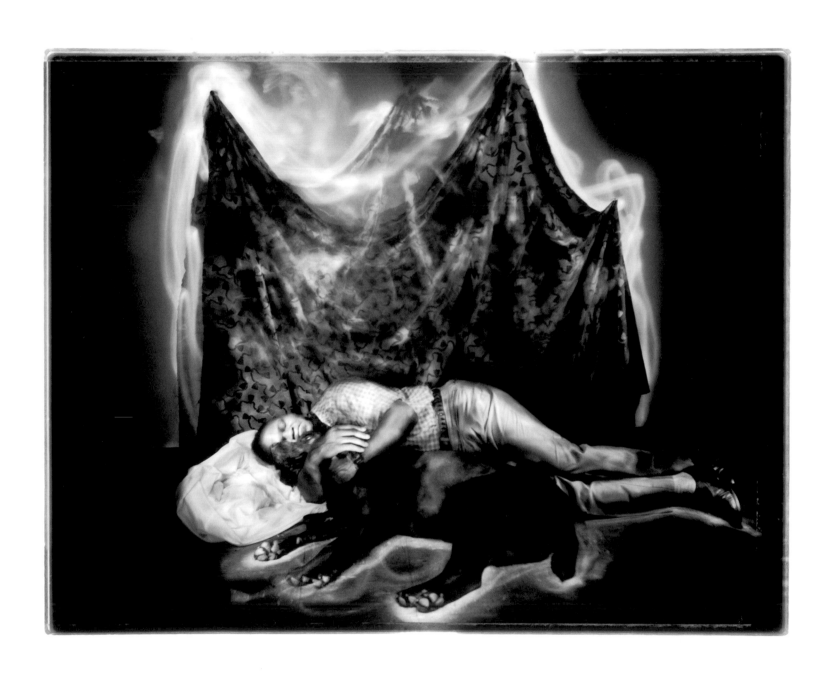

John and Headar 2 by John Gardner, Mark Andres, and Steven Erra

right: *Blindfolded Self-Portrait* by Steven Erra **42**

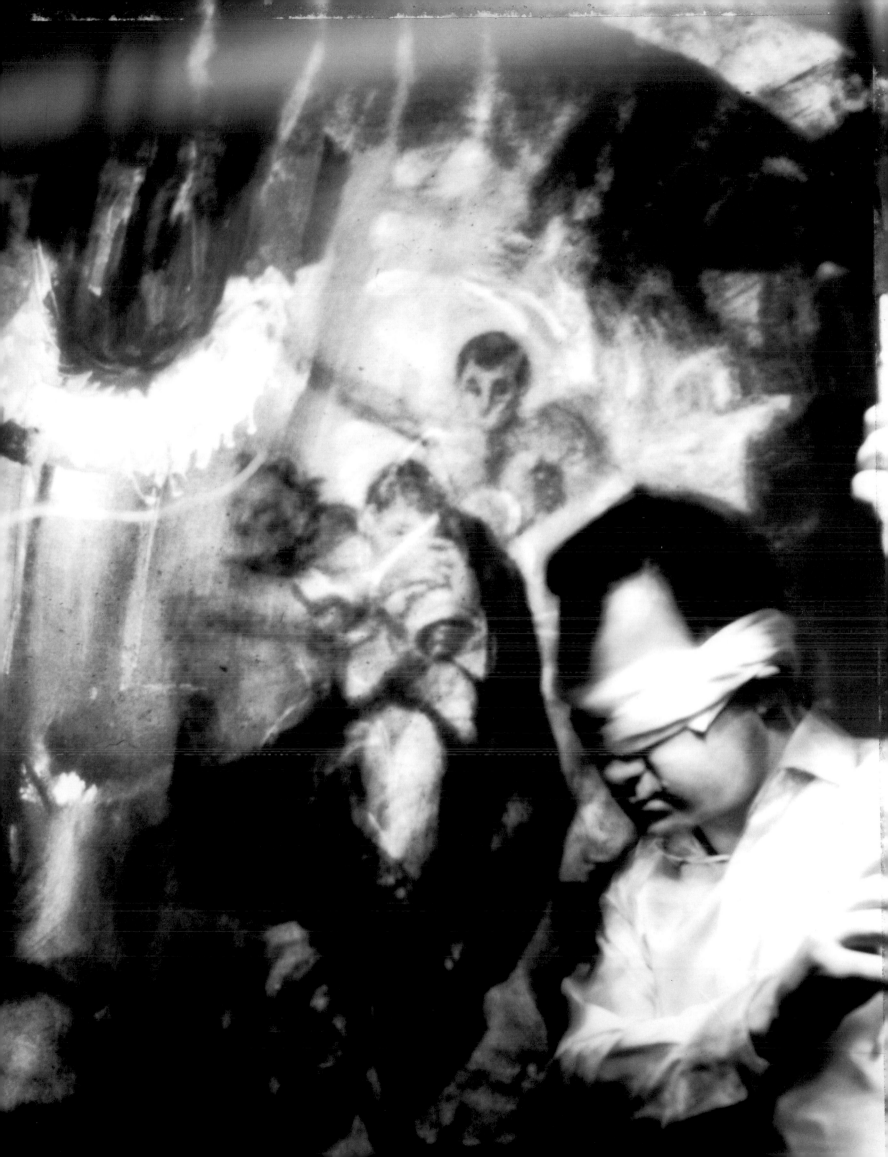

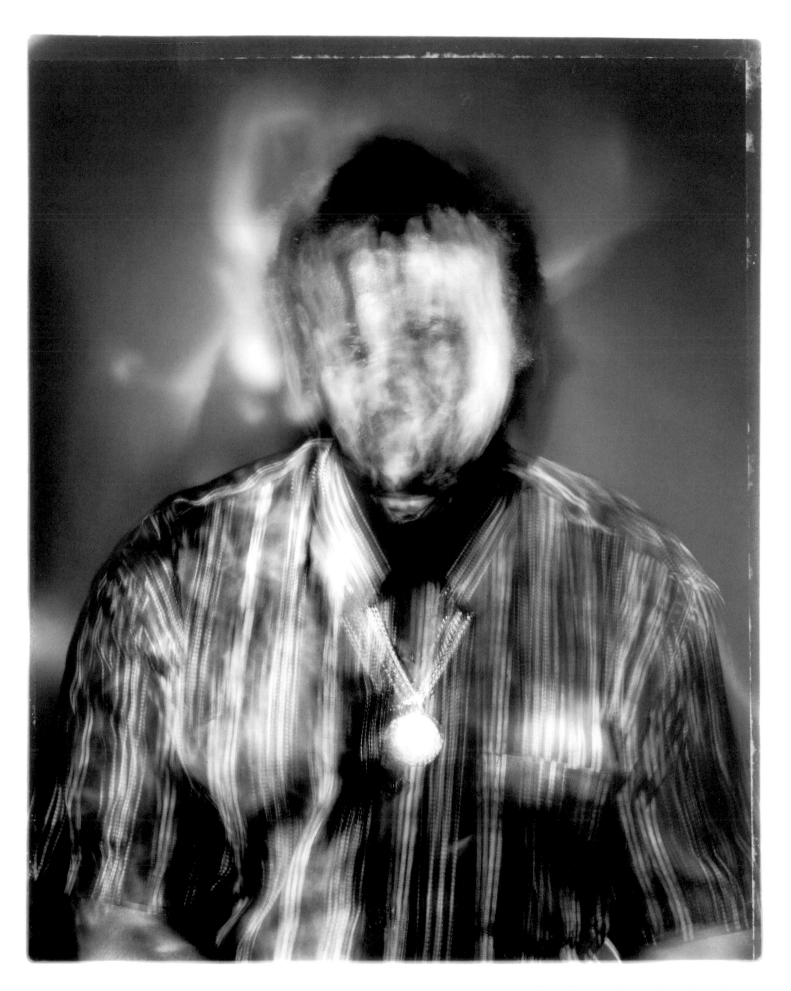

Great Head by John Gardner and Mark Andres **44**

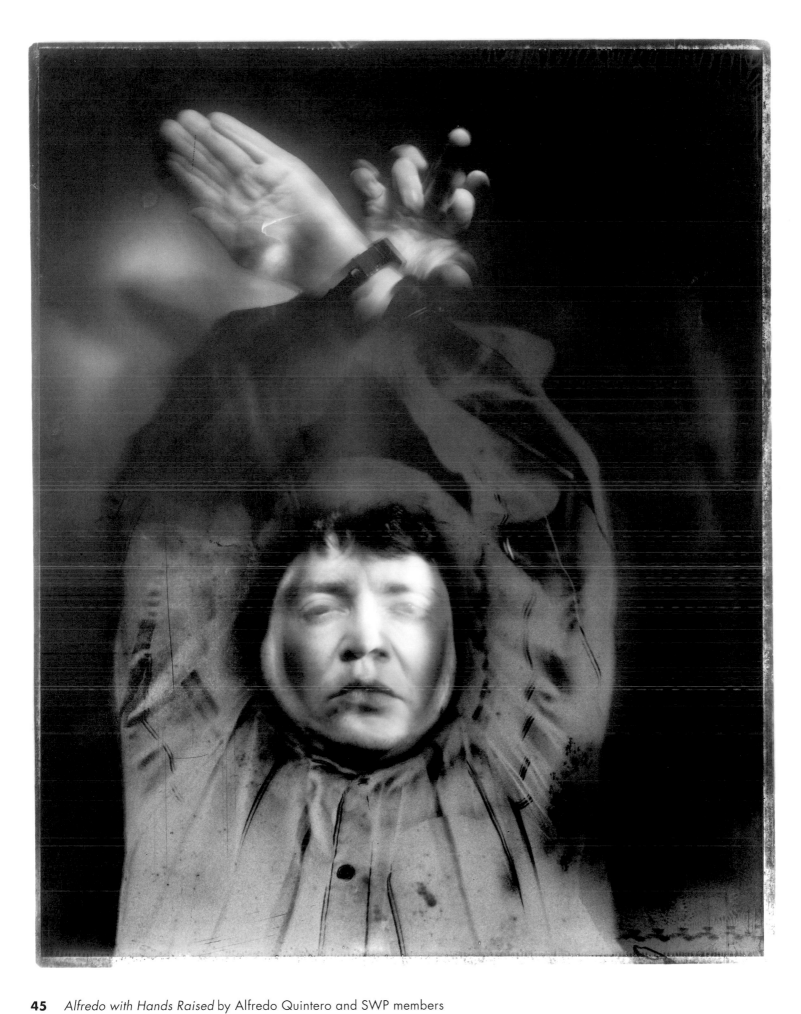

45 *Alfredo with Hands Raised* by Alfredo Quintero and SWP members

interview with **john gardner**

John: I'm from Buford, South Carolina.

What is the extent of your vision? **I still see, but my vision is not as good as it was before.** Like taking a picture, it depends on the lighting. I can see the image if it's in bright light. But after it's printed, I can't see it.

I lost my vision when I came to New York. In junior high school, I got a fever and my skin started peeling and it affected my eyesight. My vision further deteriorated in high school. I could see the blackboard until I got into the tenth grade. In the eleventh and twelfth grades it really affected me. I couldn't see the blackboard. Now I can see if I'm on the street and it's a sunny day, then I can see people; I can see the cars when I cross the street.

Were you involved with photography before you joined the collective? **I used to take pictures but I didn't like how they turned out.** When I could see, the pictures weren't that good. What I like about photography is the printing.

What do you like to take photos of? **Most people prefer to take pictures of people.** When I take pictures, I like to take pictures of animals, because I love animals.

How do you like the process of taking pictures with a flashlight opposed to your auto-focus camera? **It's a different way of photographing.** You have to think more. You have to use your imagination more.

Do you pay more attention to things now than you did when you could see more clearly? **Yes, that would apply to everyday life as well.** You take a blind person and they are more careful with a child, with a machine, than a person who can see.

What do you think your self-portraits relay? **I look at myself like there is nothing I can't do.** Nothing I can't conquer

What do you think is the best thing about photography for you? **The best thing about photography for me is that I take the pictures and turn around and print them.** I show people that: Hey! Blind people can take pictures. Blind people can let others know they have minds, and can think for themselves. I speak to myself!

Do you want people to know you are blind when they see the photos? **It doesn't bother me.** A lot of people don't want people to know they are blind. It doesn't bother me because I can do as much as anyone else can; I just have to work harder for it.

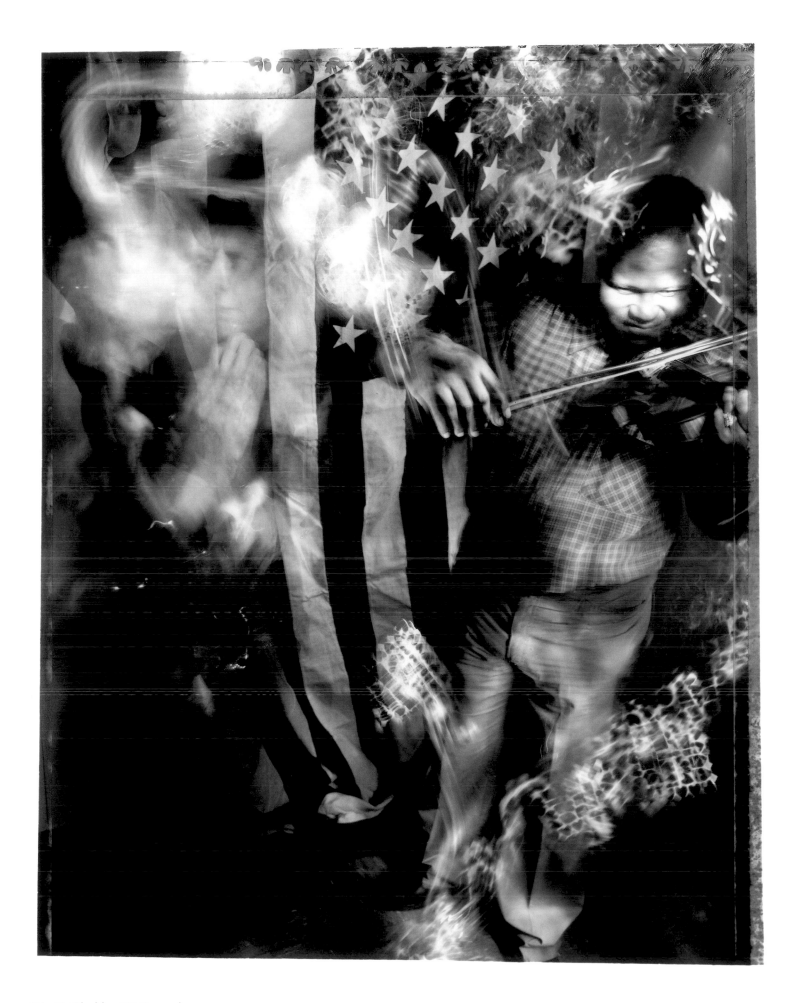

47 Untitled by SWP members

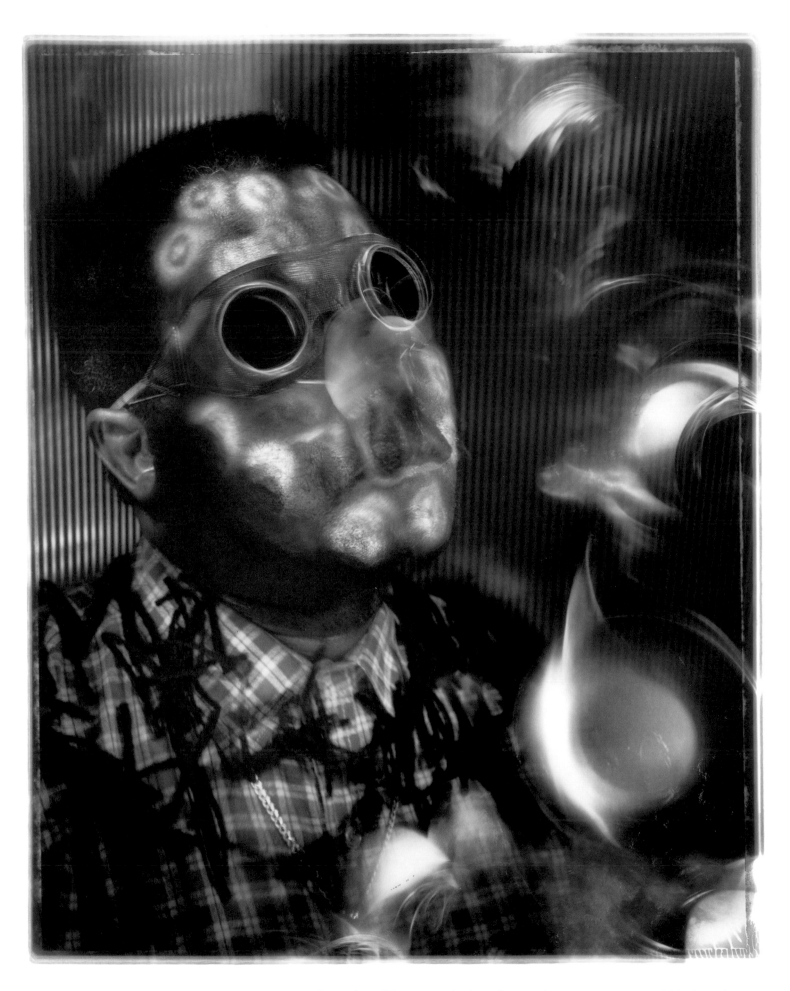

John with Welder's Goggles by John Gardner, Steven Erra, and Mark Andres **48**

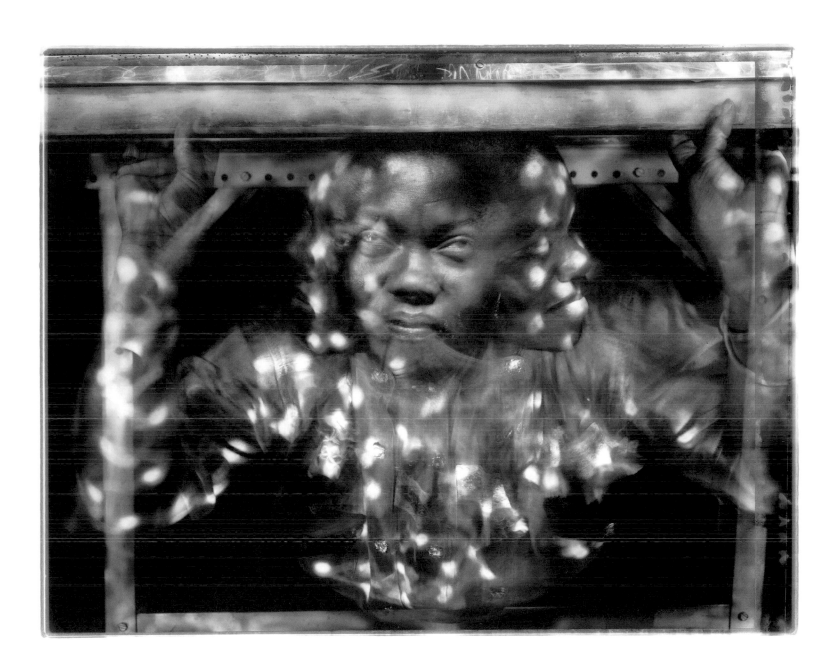

49 *The Tunnel* by Victorine Floyd Fludd with Mark Andres

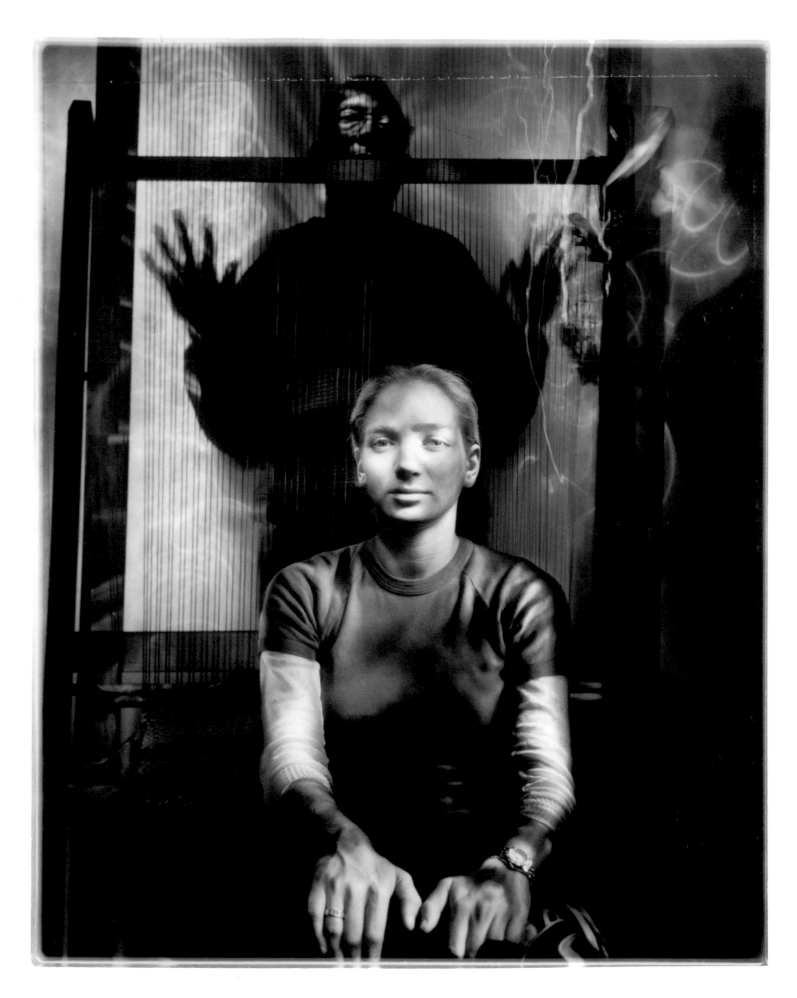

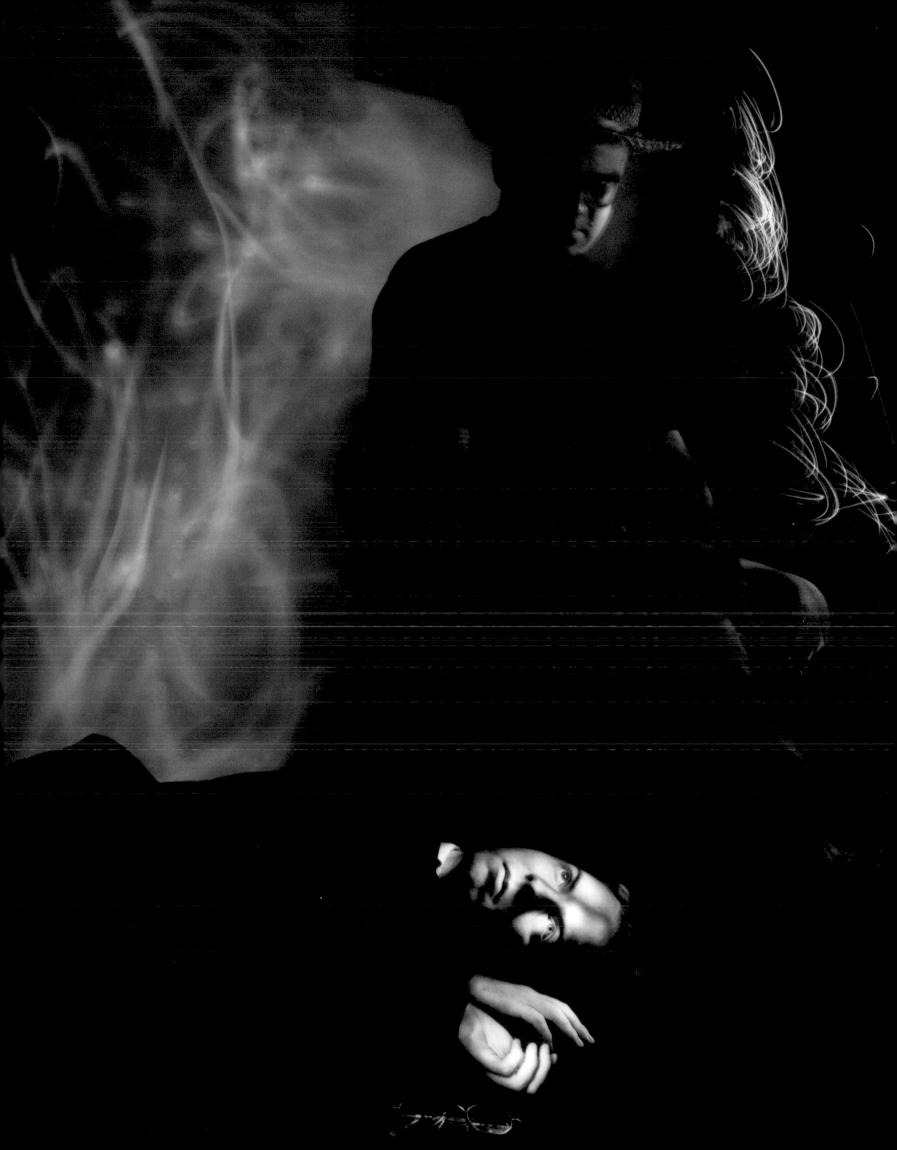

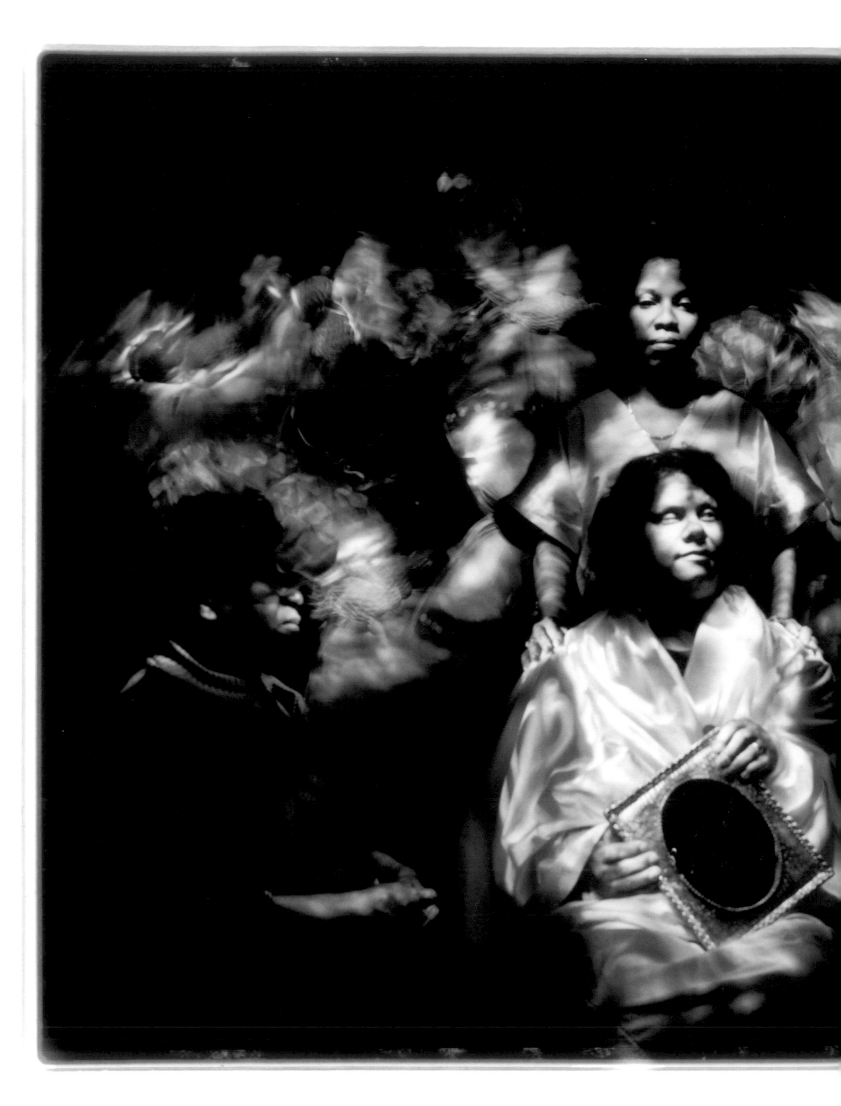

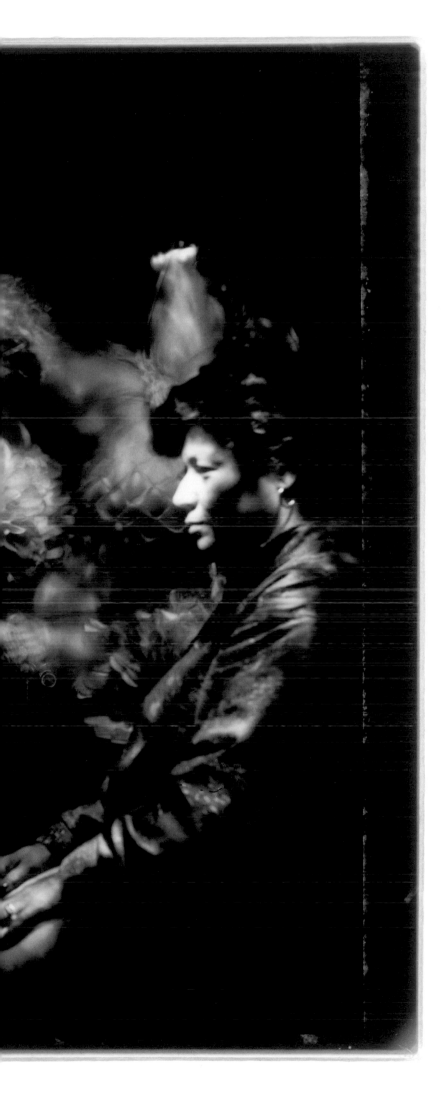

Woman with Mirror by Steven Erra
and Mark Andres with SWP members

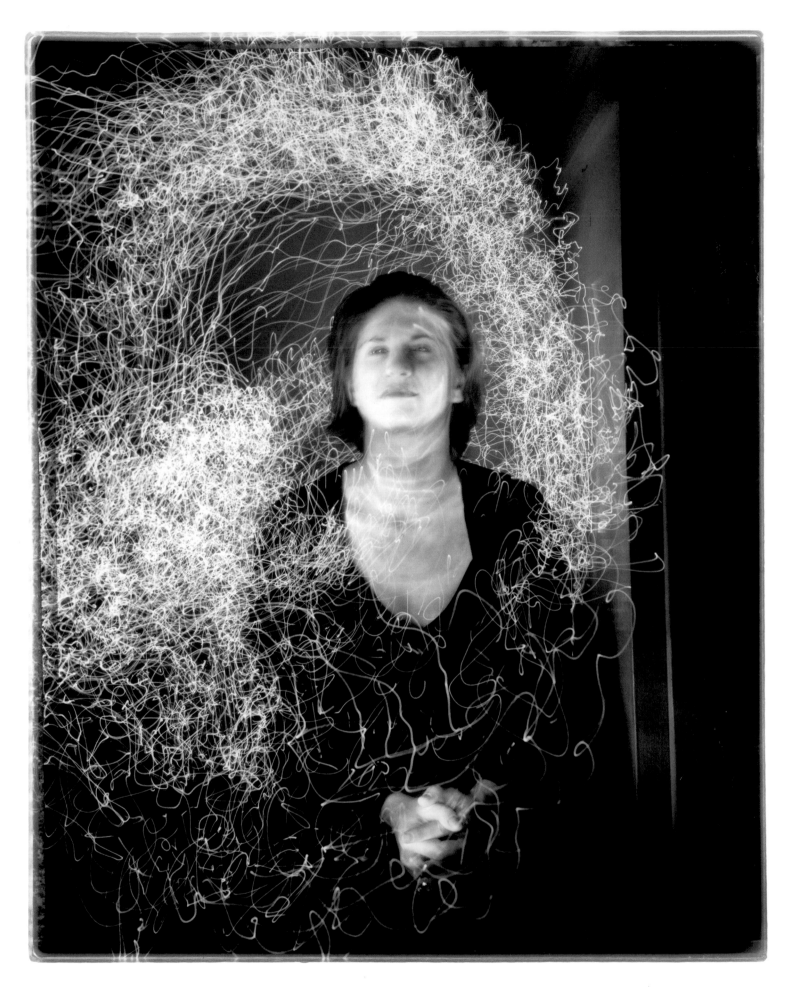

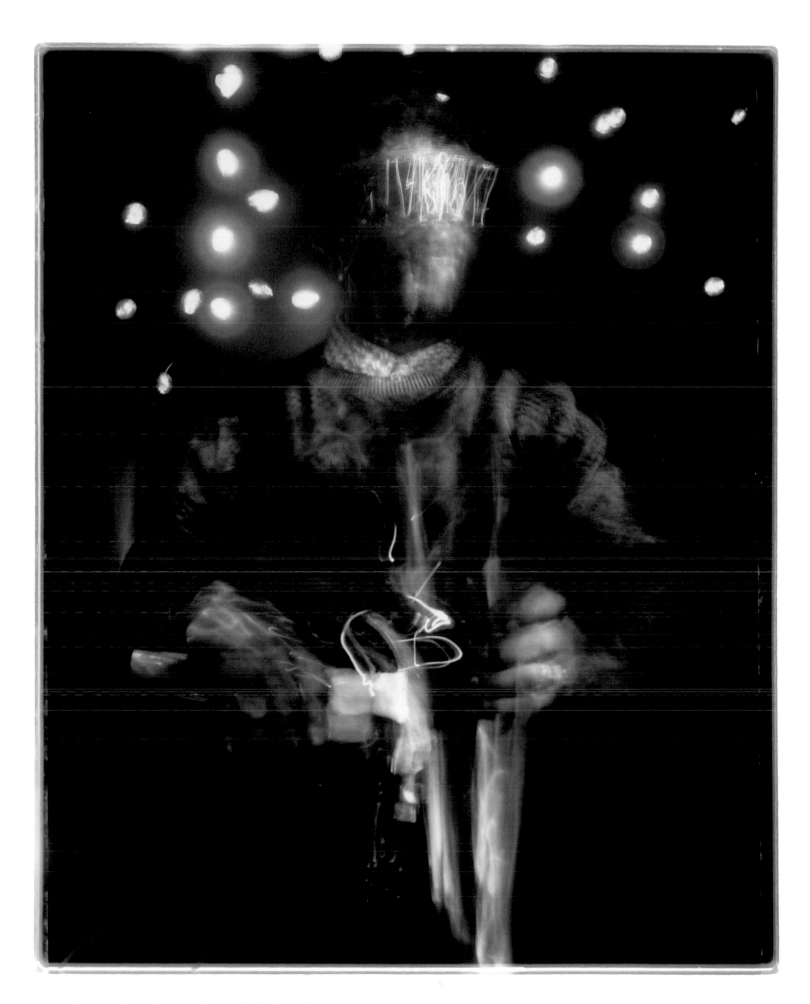

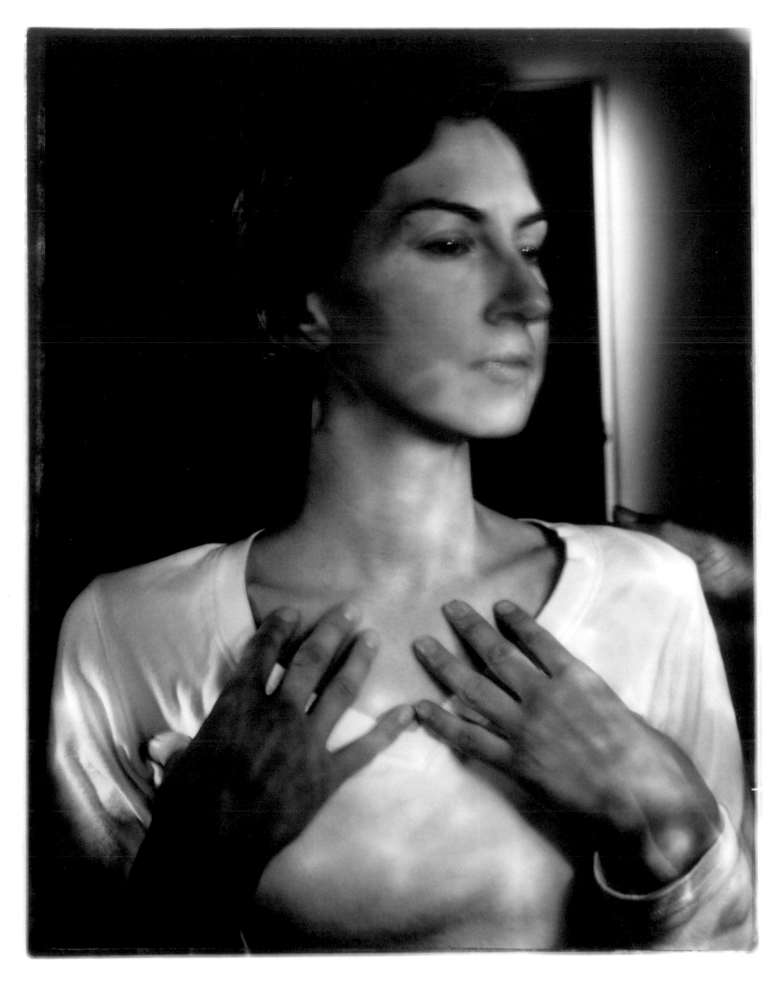

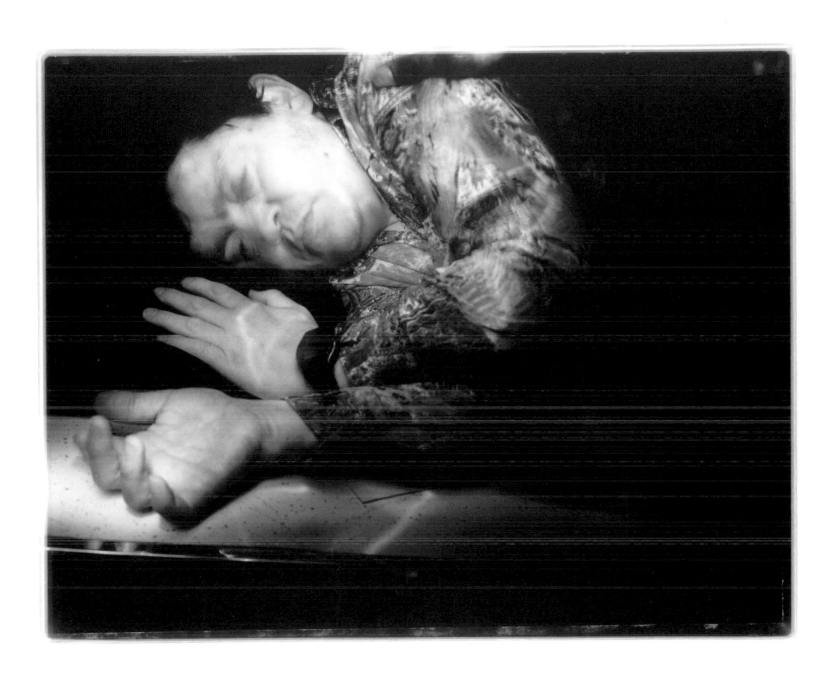

57 *Alfredo Asleep* by SWP members

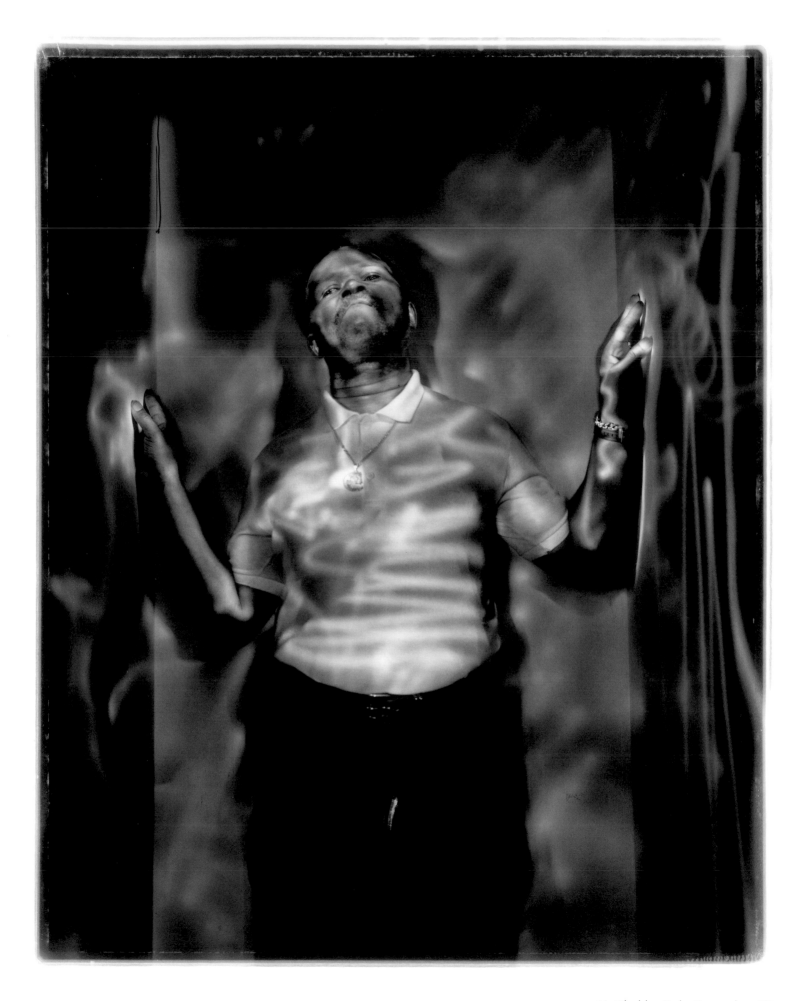

interview with **steven erra**

Steven: I was born in the Bronx, New York.

When did you first start becoming involved in the arts? **I started doing artwork in 1976.** I took a painting course in college, and I loved it. I have continued with art since then. I started taking photos before I started painting. I was initially visually more attracted to photography. As a teenager I remember looking at photography books. I remember being really mesmerized by daguerreotypes. They were incredibly interesting because the subjects had to sit still for a long time, while other elements were moving. I remember the first picture that really struck me was the first photograph of a person standing on a Paris street. I was just looking at this picture and I was thinking: Wow! It's so odd that this person would just be standing there and everyone else wouldn't be recorded but he was—everyone else was all ghostly because they were in motion. That was my first memory of a photograph being something other than just a snapshot.

Do you think you are drawing from daguerreotypes in the work that you're making now? **Yes, that's one of the things that draw me to these photographs.** There is that

blend of sharpness and blindness that a lot of pictures don't have. They seem to be either very sharp or all soft focus. What I like about these pictures is that your eye goes from one place to another and things change.

How do you think that is related or unrelated to how we see in life outside of the photograph? **Mark and I talk all the time about how most people don't really see.** They don't pay attention visually to things other than just reading them. If you slow down and take the time to observe the world, you do kind of see things that way. I only see parts of things at a time, very small areas at one time. These pictures that we're taking now concentrate on one area at a time. A sharpness, a blurriness, a sharpness, a blurriness, your eyes are always going from one to the other, which is how I view the world, too. It's very different, but also similar to the way I see the environment because I don't have a whole perception of everything. I have a very small perception of things.

This method of photographing is good for me personally, because I can control the picture. I can control the set-up. I can control where the person is sitting, how they are standing, what the angle is, how high or low

the camera is, what objects are in the picture. It's a very slow process. I'm drawn to the control over the image because I don't have so much control in other ways.

What photographers are you drawn to now? **I like John Dougdale.** I'm not too keen on photography right now. I don't know too much about it. I see a lot of the trends. I think the American public is really deluged by the media.

I like Barbara Ess who works with pinhole cameras. I like pinhole photography, although I've never done it. I like the very simple imagery, the consistency of the tone. Some older work I have been influenced by are the portraits by Hill and Adamson and the pictures by [William Henry] Fox Talbot.

Can you describe your sight? **I have retinitis pigmentosa.** A simple way to describe it is extreme tunnel vision. I see the way you would see through something probably a little bit bigger than a straw. At nighttime or dusk, when it's dim, the only thing I can see is very extreme bright lights. In dimmer light, I don't have any vision. It just vanishes, because the part of my retina that is responsible for sensitivity to light is being destroyed. It's actually dying. It dies from the edges out towards the center, which makes a tunnel. So the sensitive

areas of light I don't see at all. I can only see in very bright light.

Is there a treatment for this condition? **No.**

So eventually you will not see. **Yes, that might happen.**

Would you still be making photographs then, the way that some people here do, without any sight? **I haven't even thought about it.** I think probably I would. By doing these photographs we stay connected to the visual world. We are not just the blind world. We have the connection and we reach out. We can show the visual world that we exist too and can make something of value.

Is there a lot of cross-pollination between your photos and your paintings? **I think there is going to be in the future.** The photographs are so beautiful I'm going to use them more and more. In my paintings, I've started to use the light streaks we do. I also use a lot of my artwork in my photographs and vice-versa.

When people look at your work, do you want them to know that you have a visual impairment? **I think it would probably be more interesting for them to know.** But at the same time I want them to be able to stand by themselves.

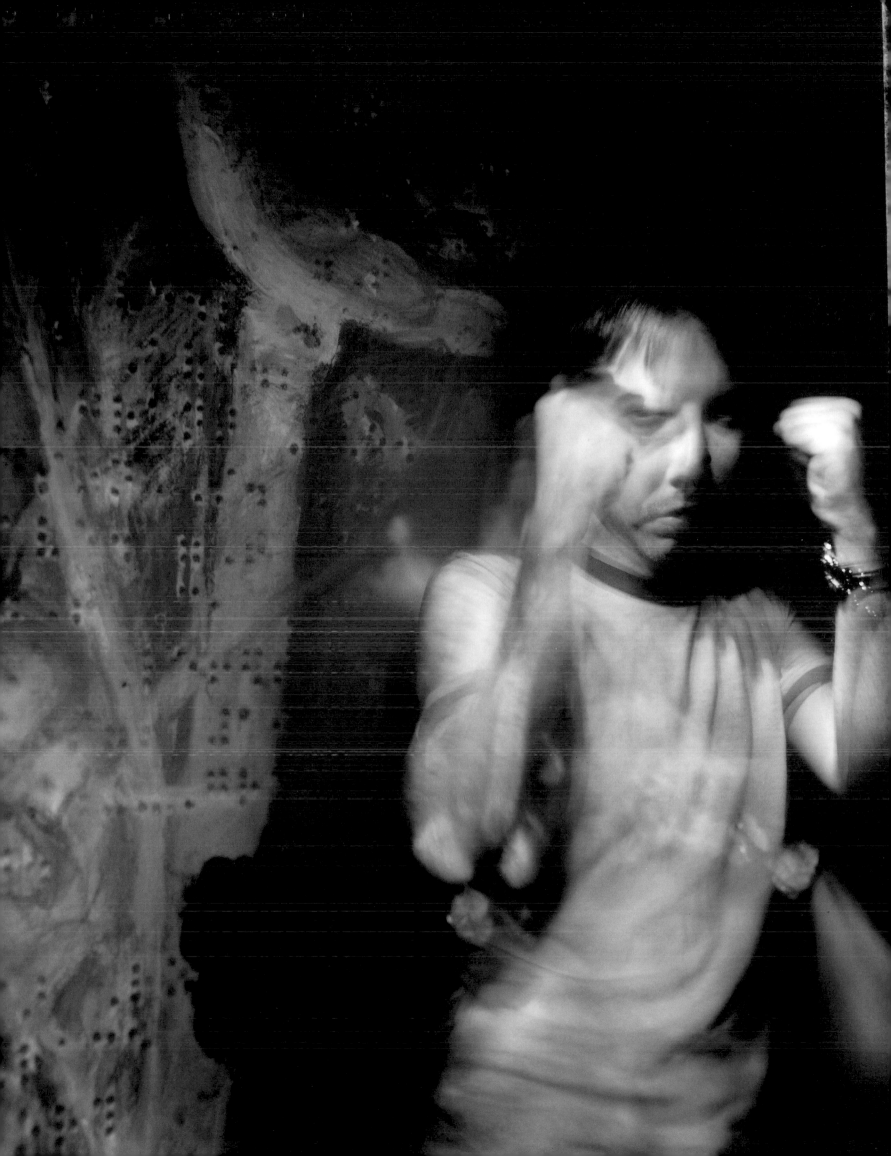

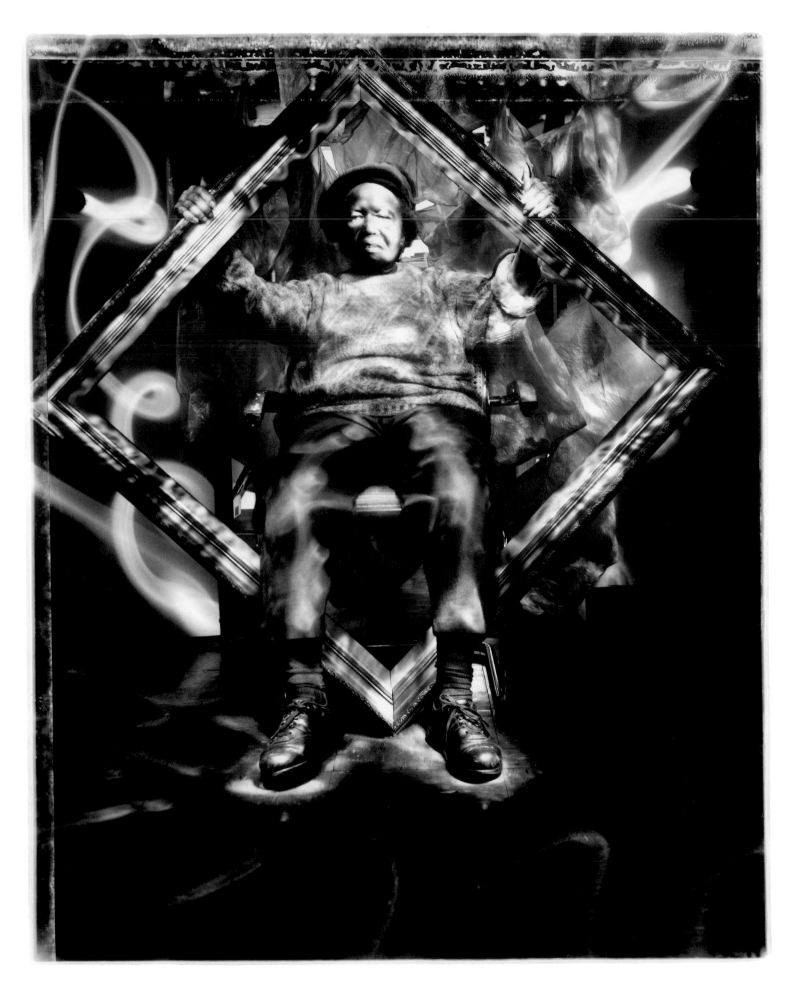

Portrait of Esmin Chen by Stephen Dominguez **62**

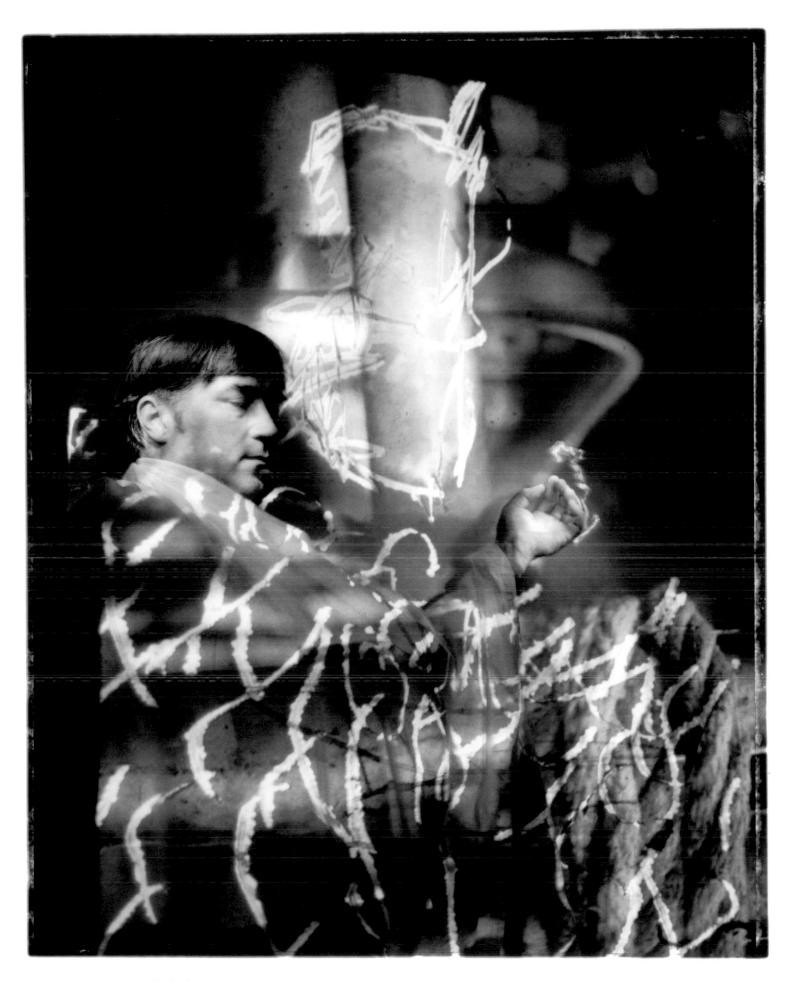

Mark Andres by Steven Erra

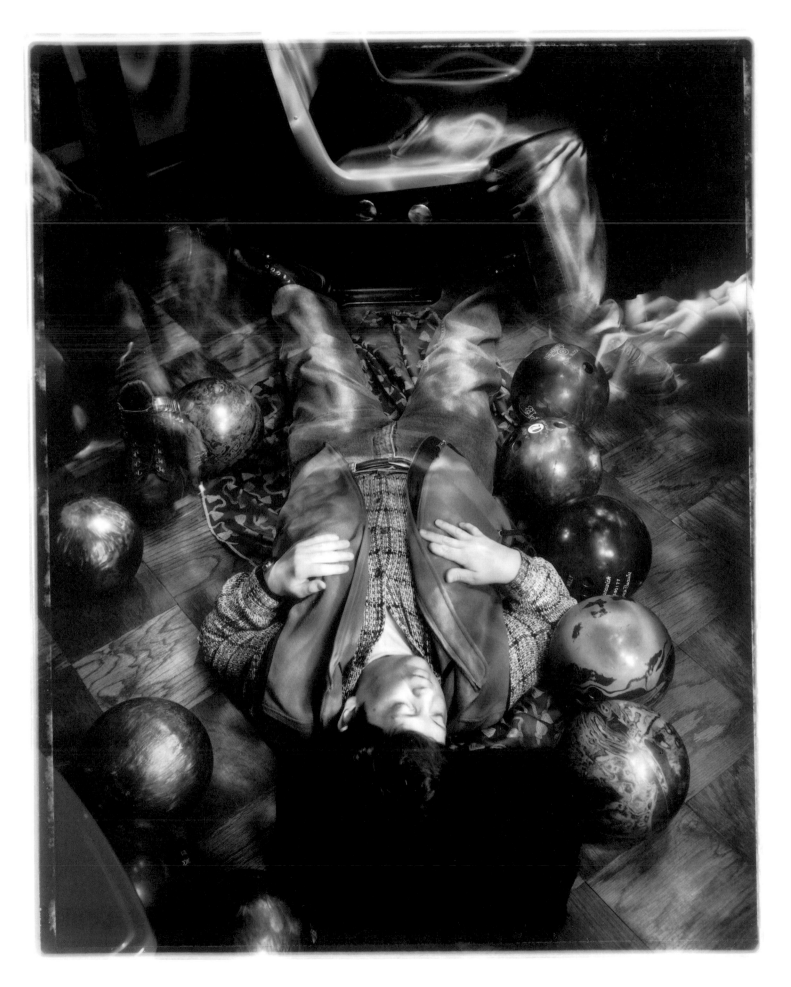

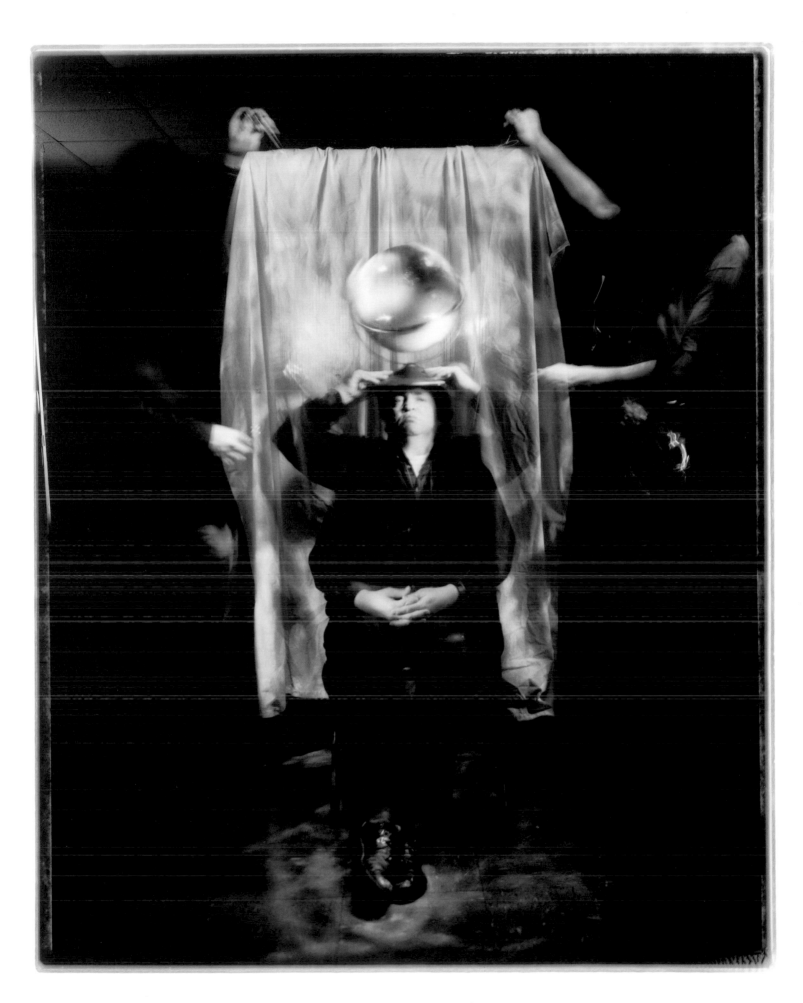

65 *Four Lights, Globe, and Background* by Alfredo Quintero and SWP members

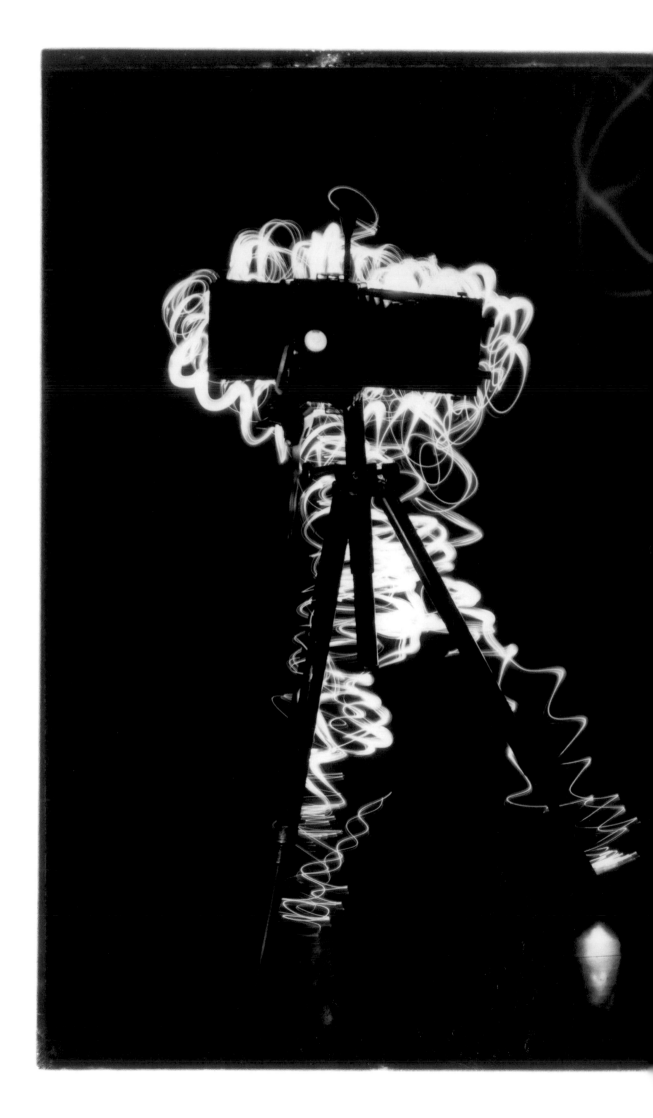

Portrait of Daryl 2
by SWP members

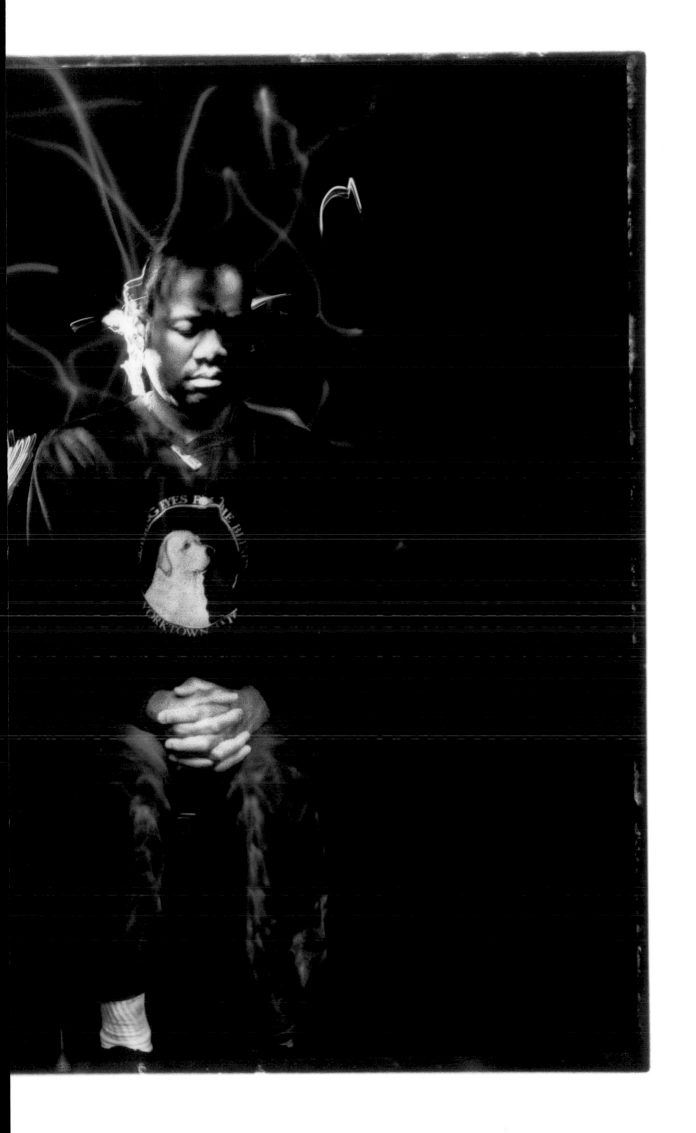

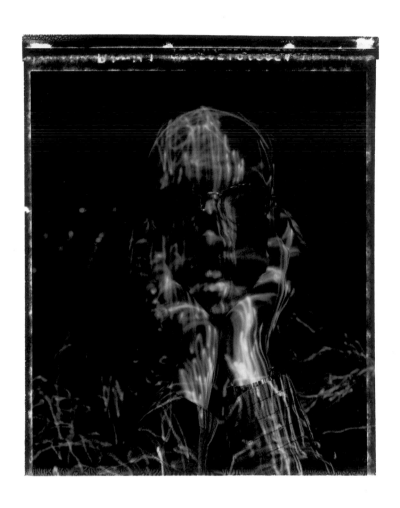
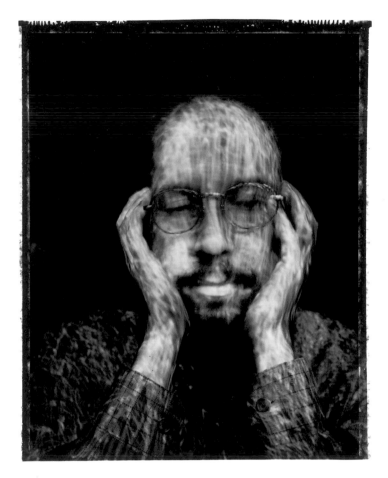

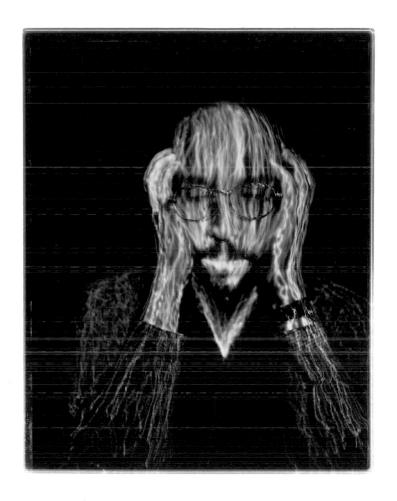
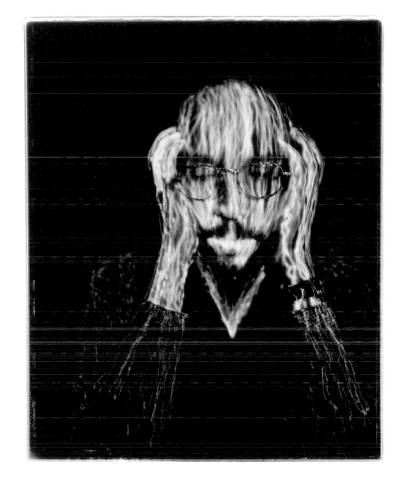

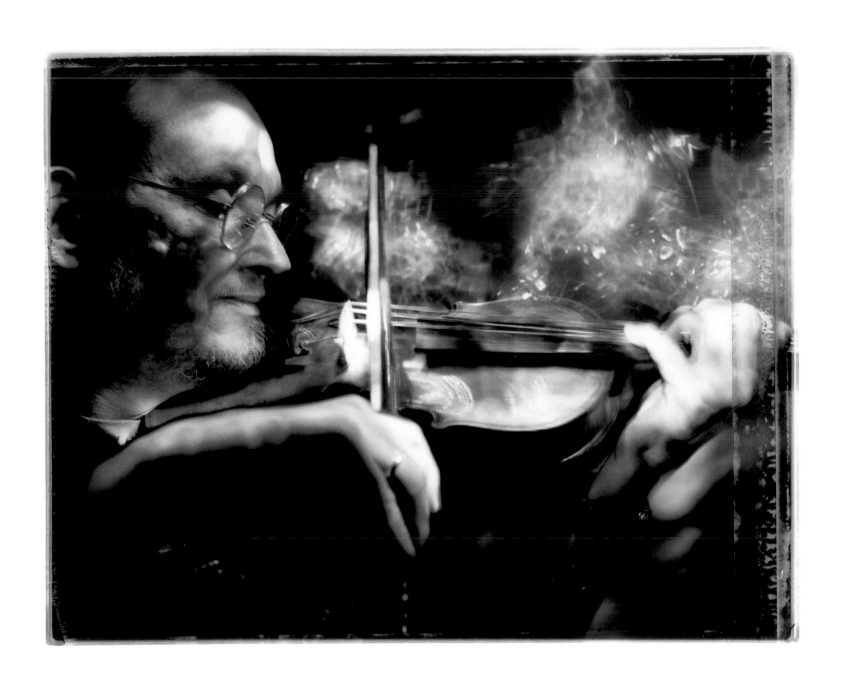

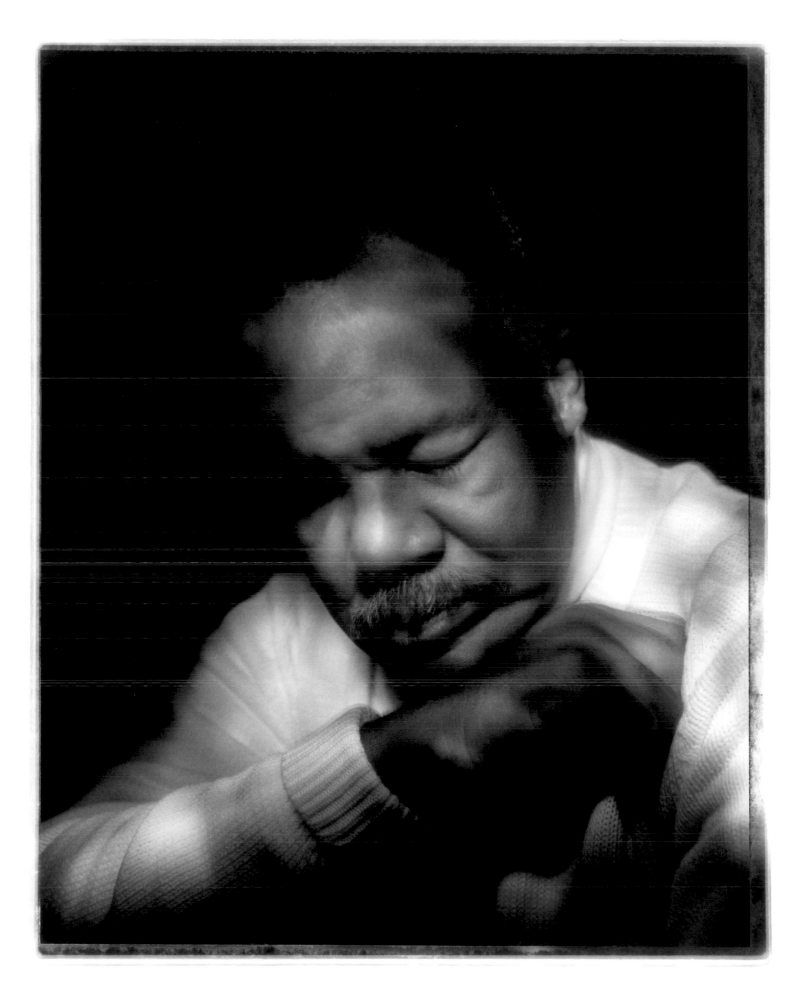

71 *Alton* by SWP members

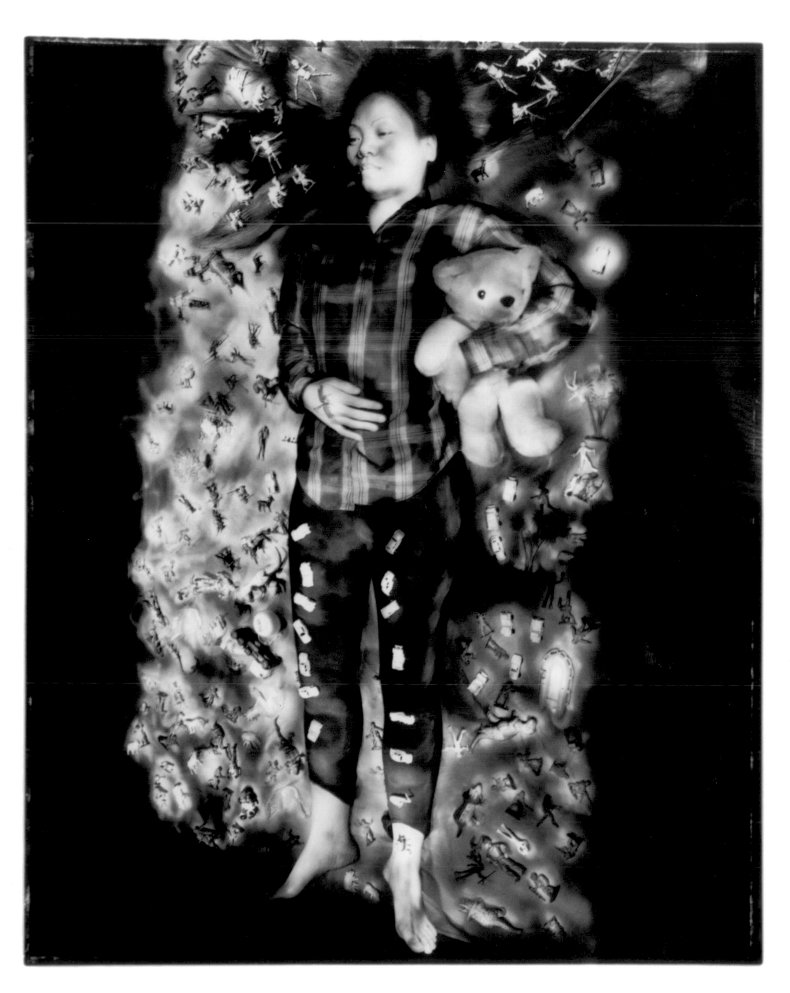

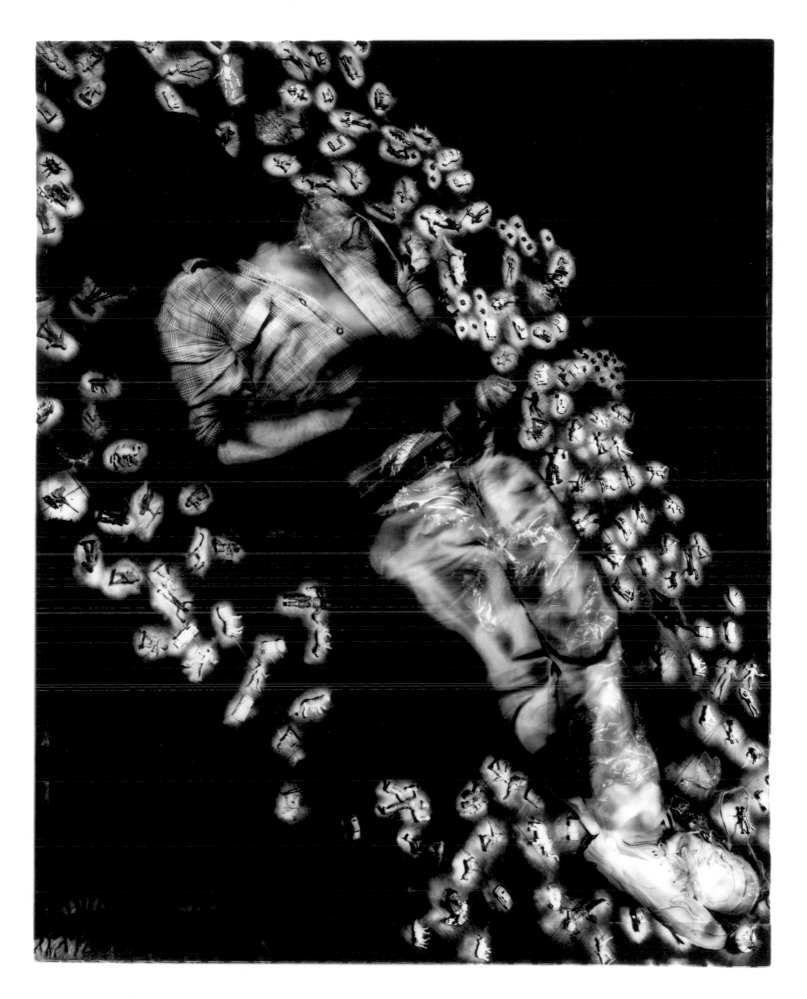

Imagination by Stephen Dominguez

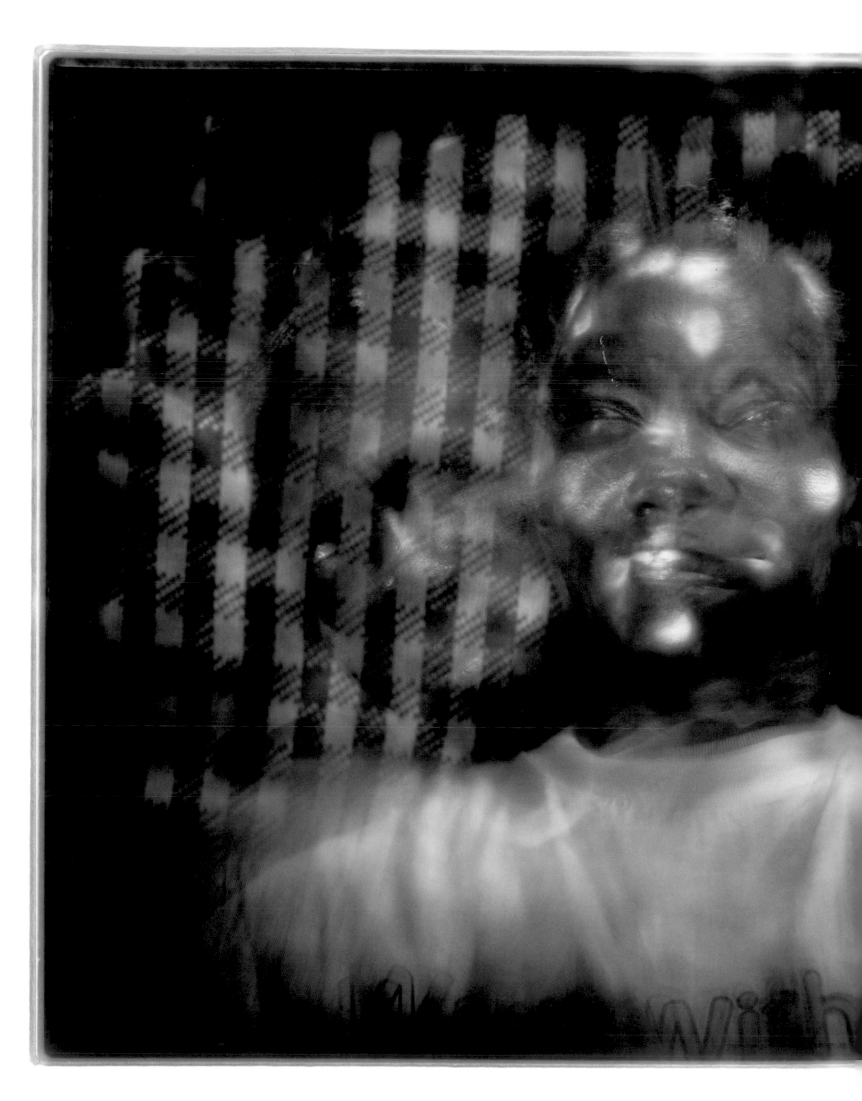

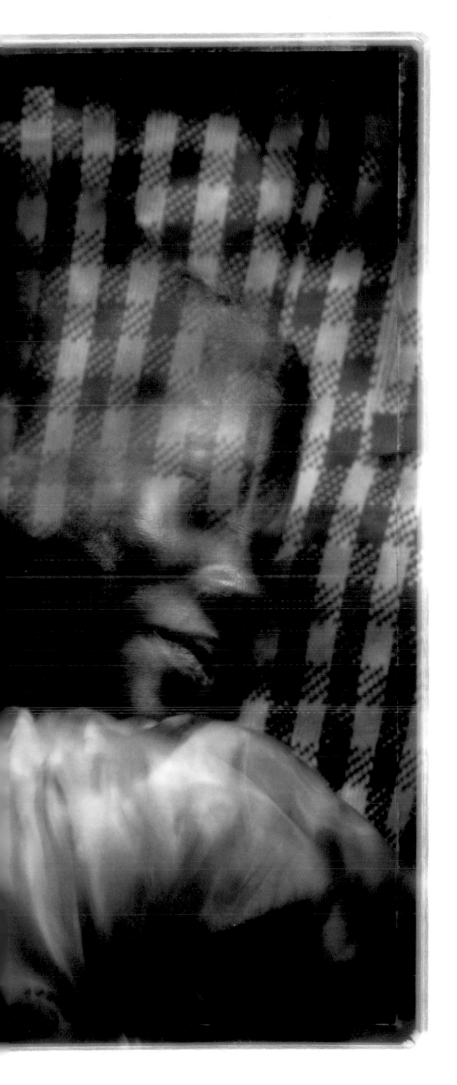

Three Heads by Victorine Floyd Fludd

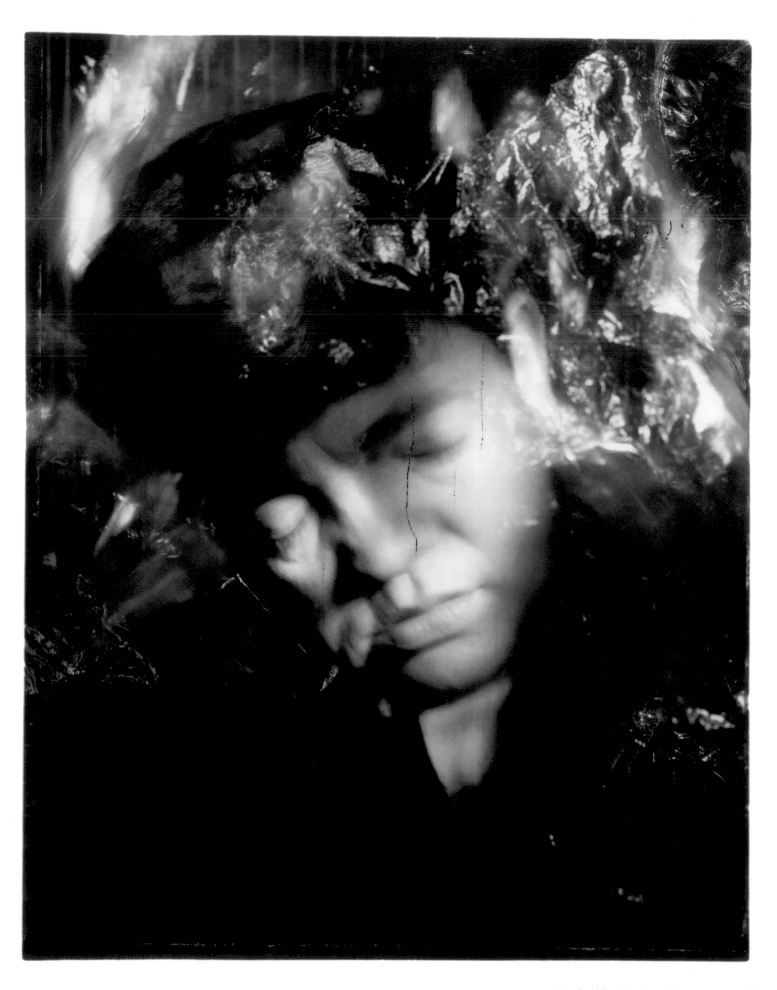

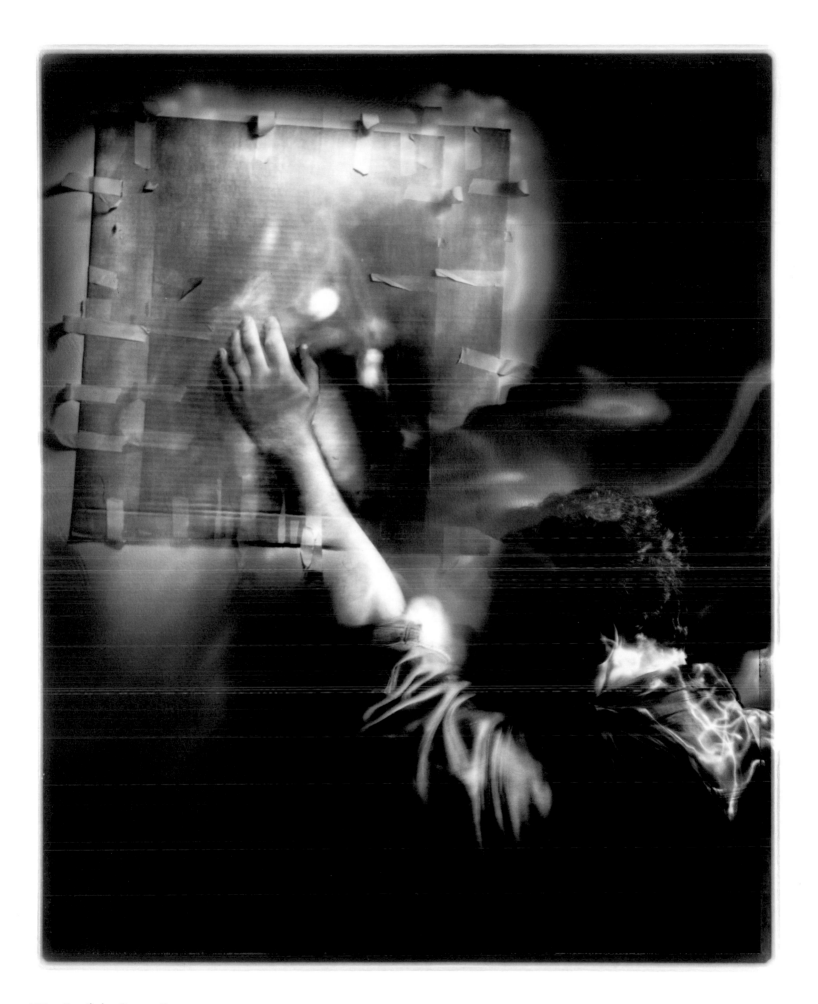

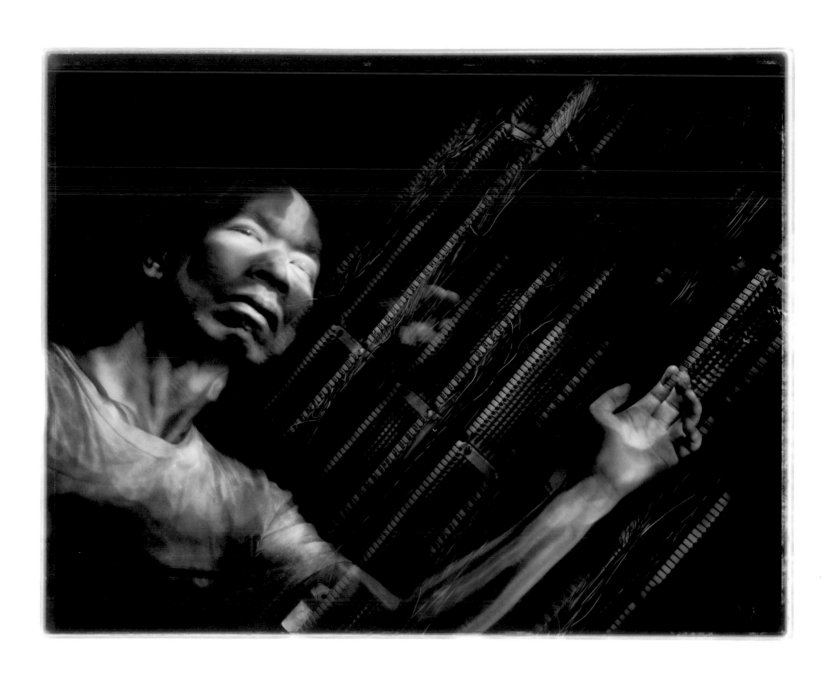

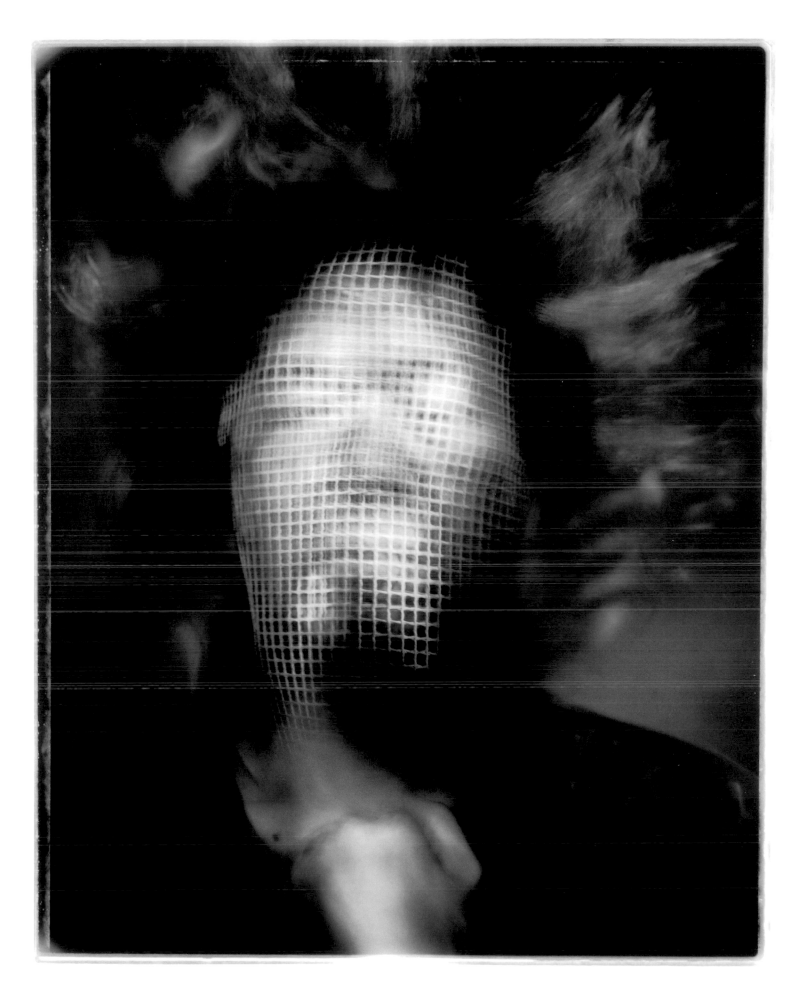

79 *Meshed* by Peter Lui with SWP members

interview with **peter lui**

Peter: I live in lower Manhattan, in the Lower East Side, just outside Chinatown.

I grew up here but was born in Hong Kong and came here when I was five. I went from Hong Kong to Japan to Hawaii to Seattle to here. They thought it would be a better life for me here and my grandparents were here.

What is your first sighted memory? **It was a long time ago.** I have this image of me being carried to my parent's home. Other than that I can remember things here and there. I can remember the monsoon season when all of the sidewalks were flooded and kids were playing in it. My sight was normal then.

I didn't develop my eye condition until I was six or seven, when I was in school. I couldn't see the blackboard. I went to see different eye doctors and they didn't know what was going on. Once we moved here the eye doctors didn't know what was going on either. It wasn't until I was in my late teens that they figured out that something was wrong. They still had no idea what. Then, about a decade later, they started to have a better idea of what was going on. I found out I had macular degeneration, inverted RP [retinitis pigmentosa]. Basically, I have no central vision at all. I use my peripheral vision and the peripheral vision I have is less than everybody else's. The central blackness is expanding and pushing all the center vision that I have out towards the edges. One of these days it will cover my entire field of vision. The doctors don't know what to do yet.

How long do you have until there is complete darkness? **Everybody's condition is different.** There is another member that has the same condition that I have. She developed it later in life than I did and she sees better than I do. So as I said, everybody's different. I also know someone whose girlfriend's condition is the same as mine. She's younger than I am and her condition is going to worsen much faster than mine. She smokes which makes your eye condition worse. I have some night blindness too. I have to use my peripheral vision to get around. I still go out at nighttime. I miss details, people's faces. The details of faces are what give people character and I can't see that very well. It's very hard for me to recognize faces.

When did you first become involved with photography? **Maybe eight or nine years ago, in the early nineties.** I was always interested in photography. When I first came here for elementary school, they had a photography class. We used Polaroid cameras. We went out and took pictures and I liked it. I've liked it ever since. My vision was a little better then. I could

still recognize faces. Now I basically have to use voices to recognize people.

Do you think that being more attentive to other senses has helped your photography? **In certain ways, yes.** Some of the photographers here use their hands to show where they want to guide the light. It makes you more aware of what you want to do because you can't see.

How is the process different from that of someone who does not have a visual impairment? **Most people take their vision for granted.** So a lot of times they don't pay attention to what they see or what they take pictures of. For those who have limited vision, they pay attention to the details, shapes, and how they contrast with the background.

Even the blind have different styles of taking pictures. It's kind of sad that the blind don't see it that way. They think, you can't see, well you shouldn't be taking pictures, you shouldn't be painting, you shouldn't be drawing! That's defeatist thinking right there. If you're blind, so what? Why give up, just because you can't see?

What do you see in front of you? **It's very difficult to understand.** I see darkness. I see lights flashing. But there is no border as to where I can see and where I can't see. Things blend into each other. As you go further and further into the middle of the print, bits and pieces start to disappear. Basically I see everything and then as I move towards the center, nothing. It's very difficult.

Can you see your own finished photographs? **I can see almost everything—just the detail is hard for me to see.** They are glossy to me because of the chemicals on them and the light bouncing off the chemicals. I see the lights bouncing off the pictures. This light is in the way. It is shiny and it's hard for my eyes to adjust. It's disheartening sometimes, but that's the way it goes. I can see shapes, sizes, colors, and maybe some depth. I see very well if the print has high contrast. When I take pictures, I have an image in my mind of what I want and I just pray and hope I can do it.

What is the best thing about photography for you? **Self-expression, sense of freedom, creativity.** A lot of blind people become very closed, introverted. They lock themselves in because they stay home all year round. I know enough of them who do this.

Are there photographers who have influenced your work? **To tell you the truth, not that many.** I'm not too much into the names of famous artists. I make pictures because I like to and hopefully others will like the results.

interview with **victorine floyd fludd**

Victorine: I'm originally from Antigua. I've been in New York for twenty-one years. I came here for medical reasons; they didn't have adequate medical facilities in Antigua. I am totally blind in both eyes.

Have you always been blind? **I lost my vision when I was twenty-six.** The doctors found pseudo-tumors on the brain, which caused optic atrophy and fluid on the brain. As far as I can remember, they said if I had come a little earlier, they could have drained the fluid by spinal tap. I now have spinal taps when I have headaches. The first one wasn't very painful, but when they keep doing it, it hurts. You have to curl up, with your knees up to your chin, and they push needles into your spinal chord—it's not easy.

In some of your self-portraits, there are two of you, three of you in one image. **The one with the three of myself, I named "Hercules," like my body is bigger up there and down here it is small.** I like to pose for my photos. I like to model for the others, too. I like to do something unusual with myself. That's why most of the time my pictures show three of me, five of me, anything like that.

I used to do photography when I was on the islands. I had an A 126 camera and took pictures of my kids, got someone to take pictures of me, and took pictures of other people. When I got sick and came here, I didn't think I could take pictures again. But, Mark proved me wrong when I started the class at the Lighthouse about twelve years ago. Sometimes I may cut off somebody's head because I misjudge how tall they are; sometimes a voice will be right there, but a person is taller. That's why most of the time I have to touch a person to see how tall they are so I can aim.

How do the pictures you take now differ from the pictures you took before you lost your sight? **This is more fun.** I have a certain technique with the flashlights; I always make swirls with the light. If you see a picture with a swirl that's like a screwdriver, it's mine, my trademark.

I love to take pictures. It's really fun. It's always nice when someone says, "Victorine, this picture is really good for a person who can't see!"

What do you think makes a good picture? **A good picture comes not from outside but from within.** It's a love. Just like when you love someone and you show the love. You're going to go all out to get that picture how you want it to be.

interview with **roseann kahn**

Roseann: I've been a New Yorker for a long, long time. I've been associated with this group for a little less than two years and I've really enjoyed it. I'm retired from the television industry.

Do you remember the first photograph you ever took? **The first photograph I ever took must have been when I was about twelve years old with my box brownie.** It was in black-and-white and taken where I lived, which was downtown Manhattan.

What has been the extent of your photographic work since then? **I was an art major in college and I always loved form and color.** I once had a very good camera, an Argus, and I was very fussy with opening the aperture to the right number to get the right light. I liked natural light and I really enjoyed taking pictures.

Which photographers were you interested in and influenced by? **I was interested in Francesco Scuvulo.** He would have people lying on the floor, on white linoleum, probably so that the light reflected upwards. They would have all the ladies wear a lot of diamond rings to take attention away from their hands. I always loved Avedon; he did beautiful work. And, of course, Ansel Adams.

How did you lose your sight? **I do believe, and my doctor says I am probably right, that I lost my sight from smoking.** I used to smoke four to five packs of cigarettes a day. The deadlines were crushing, killing. Everyday I worked on five shows a week and every afternoon I would have to nail down what was happening the next morning and it was really killing. That was when I was fifty; I'm seventy-five now. This eye deterioration started and I was able to function for another five to ten years. I did some more shows and then I just couldn't anymore.

How much can you see now? **It is so hard to articulate my blindness.** I can't see your face or my face but I can see everything else. I can't see the photographs very well. The Polaroids, in particular, I can't see at all.

Is your eyesight still deteriorating? **It's gotten a little bit worse in the last month or so.** The doctor said that I will never go totally blind, unless, say, a piano falls on my head.

In some of your photographs you have this very frantic light everywhere, these little scribbles of bright light. **They're Christmas-tree lights and I had to see what they would do.** So I took them out of their box,

plugged them in the wall and I tried to create a fountain with those lights.

What other pictures are you planning to make now? **I do have something in mind, but I don't know if it's going to work.** I want to show a light emanating from somebody's eyes and I know how to do that. I really would prefer to do something entirely different.

What is it that you hope other people get from your pictures? **So many blind people give up and they don't do anything.** I hope that people go out and take pictures. Don't just give up—do something!

Do you feel cut off from photographers that aren't visually impaired? **Yes. I don't see the nuances that they do.** There are two kinds of light for me: sunlight and fog.

Do you think your audience should know that the collective is visually impaired? **If they know they make excuses for us, and if they don't know, I don't know what they would think.** If the photographs stand on their own, it doesn't make any difference.

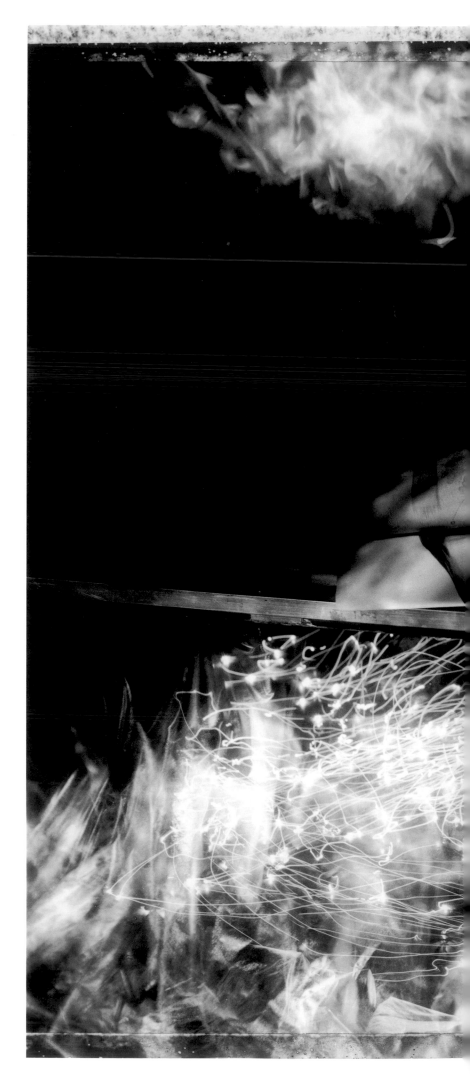

Roseann Reclining Surrounded by Light
by Mark Andres and Steven Erra

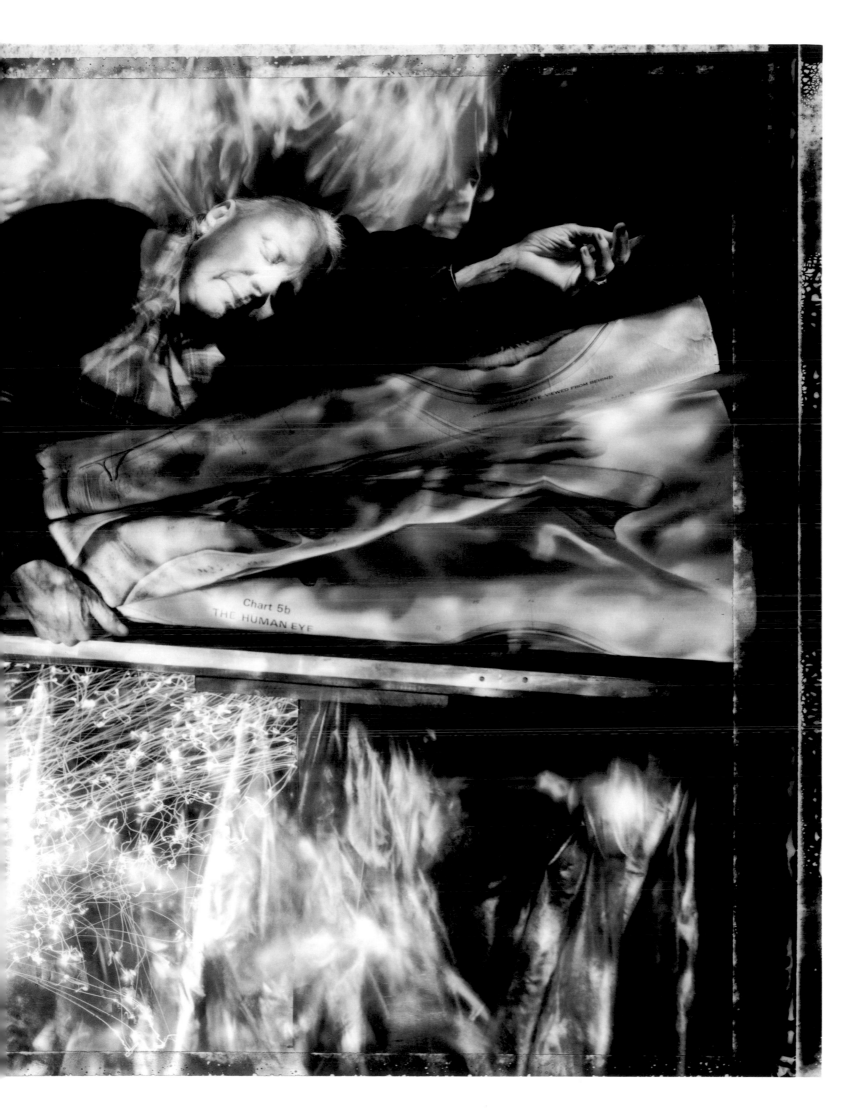

Chart 5b
THE HUMAN EYE

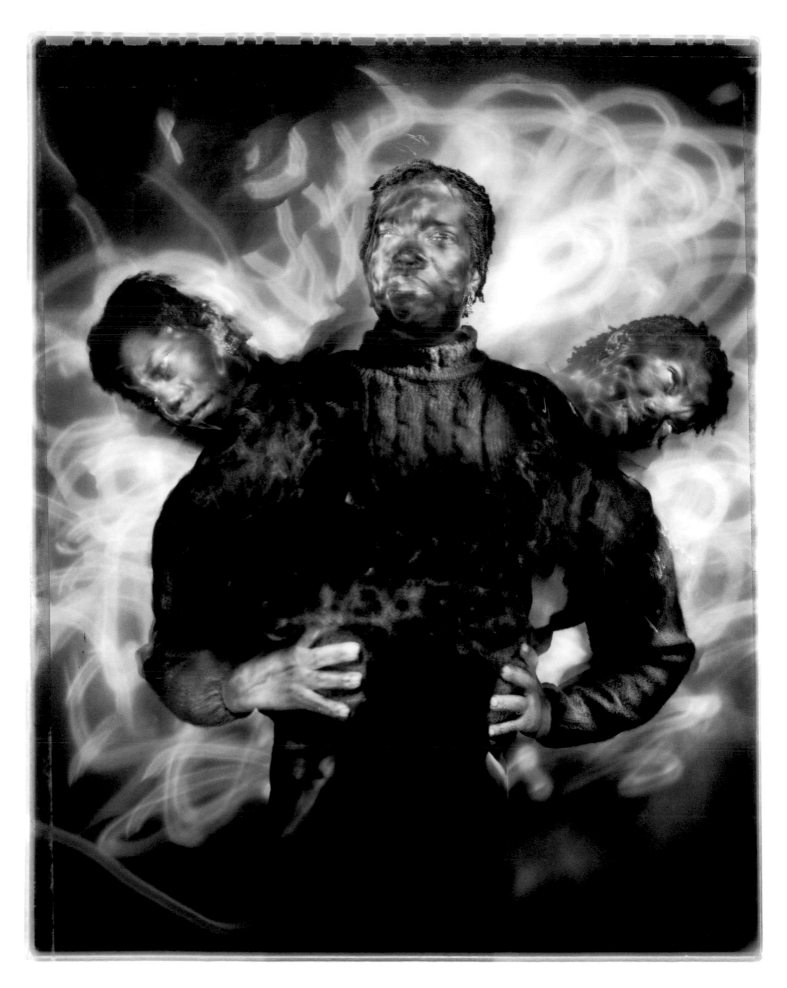

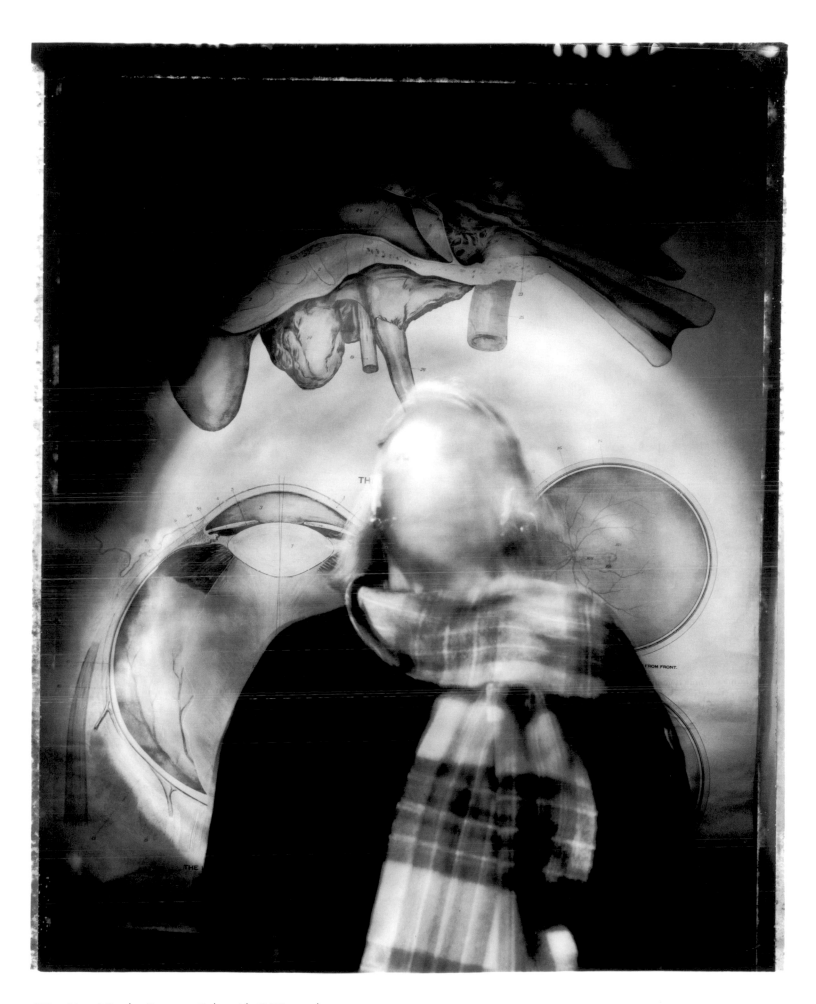

How I See by Roseann Kahn with SWP members

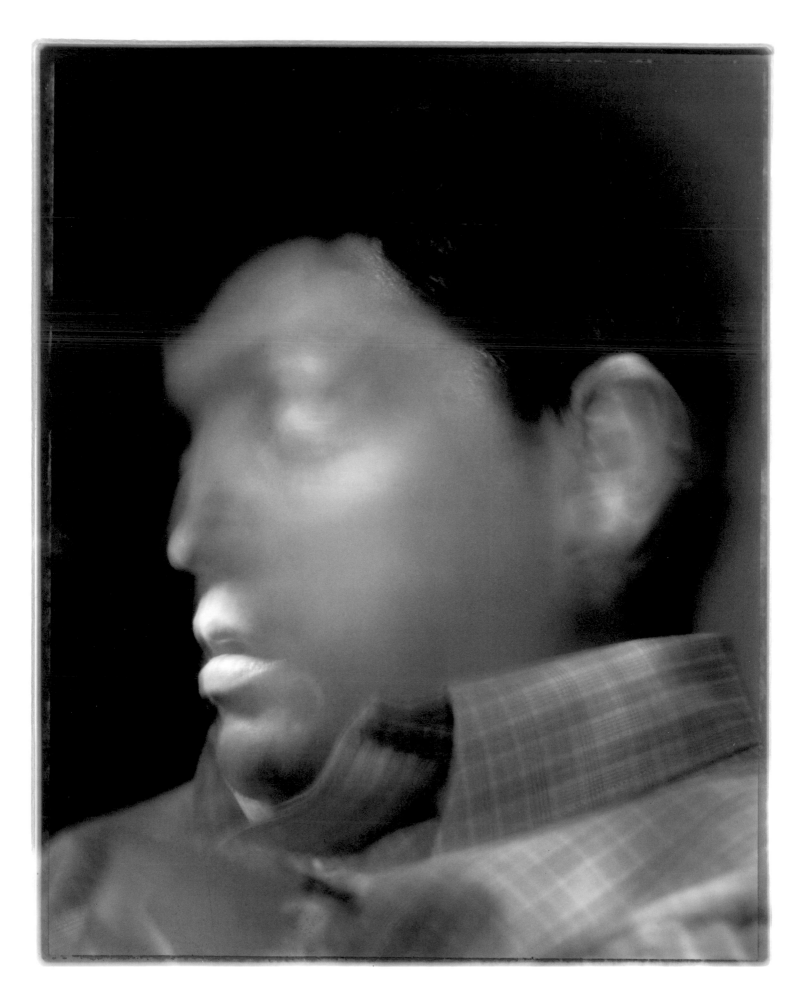

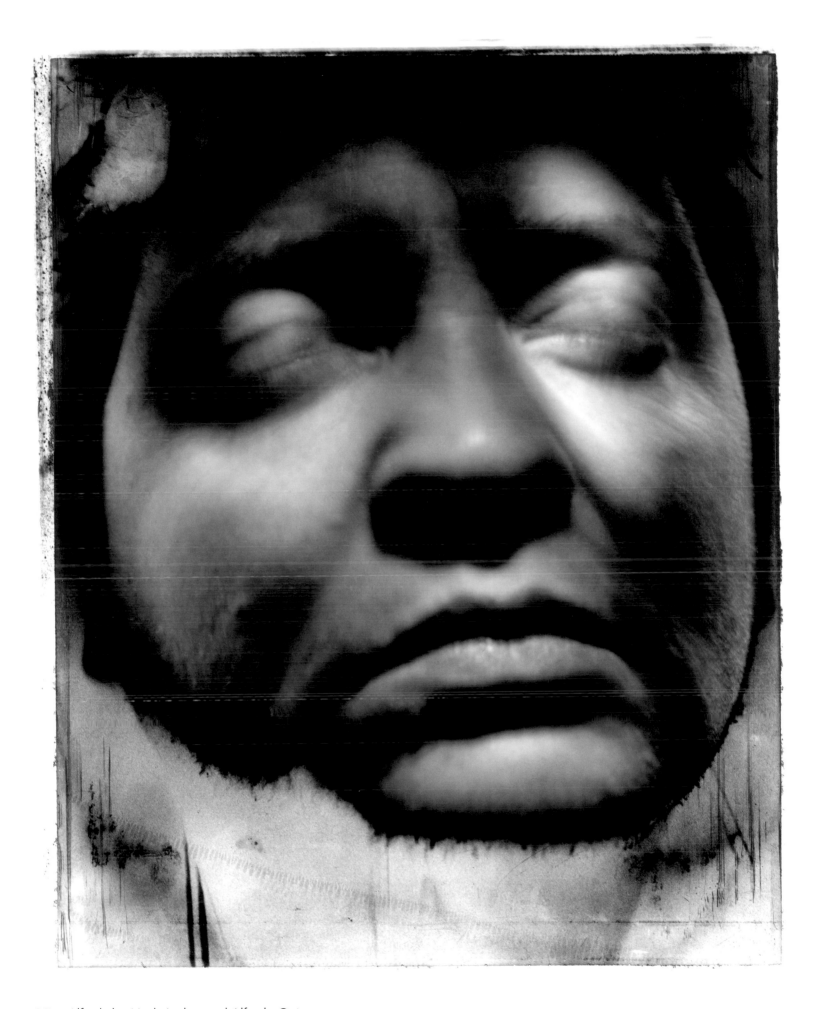

89 *Alfredo* by Mark Andres and Alfredo Quintero

biographies

OPPOSITE—TOP ROW, LEFT TO RIGHT: Mark Andres, SWP's Program Director, was born in the Panama Canal zone in 1952. His education as an artist began as a child watching his parents paint, and living in a home filled with art. He furthered his studies at Brown University and at the New York University/International Center of Photography graduate program in photography. He began working with the legally blind in 1985 and also teaches at the College of Staten Island. Mark lives in Brooklyn with his wife Judith Foster and his three children, Beryl, Avi, and Sasha.

Esmin Chen was born in Cuba. She immigrated to Jamaica as a young child. Esmin lost most of her sight as a teenager. In early adulthood, she moved to New York City where she still resides. She loves taking photographs.

Stephen Dominguez grew up in Brooklyn and has lived in Manhattan for the past three years. His experience with photography began in 1986 when he enrolled in a photography class for the visually impaired and blind. He has been hooked since. Stephen is presently enrolled in LaGuardia College's Occupational Therapy Assistant Program. In the future, he hopes to use his passion for photography to help others learn more about themselves.

Steven Erra was born in New York City in 1956. He was studying painting at the Parsons School of Design in the late 1970s (B.F.A. 1986) when he was first diagnosed with retinitis pigmentosa, a degenerative disease of the eye. The deterioration of his sight did not alter Steven's commitment to making art. He maintains a small area of useful vision that enables him to pursue, appreciate, create, and exhibit his paintings and photographs.

MIDDLE ROW, LEFT TO RIGHT: Victorine Floyd Fludd was born in sunny Antigua, and is now a resident of Brooklyn, New York. She loves cooking, dancing, singing, and photography. Vicki lost all her vision at twenty-six years of age, but that hasn't slowed her down a bit.

John Gardner was born in Beauford, South Carolina, and moved to New York City when he was eight years old. Because of his deteriorating sight, he thought it would be hard to take photographs, but that didn't stop him. He began using a camera twenty years ago and has no plans to stop.

Roseann Kahn, a native of New York City, worked with SWP for two years. She worked for the television industry for most of her life, and became active as a volunteer after she retired.

BOTTOM ROW, LEFT TO RIGHT: Morty King, originally from Trinidad, is a resident of Brooklyn, New York. He has been creating pictures of land, sea, air, and the spirit for over fifteen years.

Arthur Krieck, a native of New York City, is a classical musician and teacher. He was educated at the High School of Music and Art, the Mannes College of Music, HB Theater, and the Manhattan School of Music. He lives in Manhattan with his partner Alan and two cats, Fritza and Madeleine.

Peter Lui was born in Hong Kong, and lost his central vision as a child. He has been working with photography for over seven years. Peter is currently studying business at Baruch College.

Alfredo Quintero was born in Colombia in 1955. He moved to the United States at the age of sixteen. That same year he had an operation to remove a tumor from his brain. One of the effects of the operation was a severe disruption of his vision. This has not stopped Alfredo; for over twelve years he has been making fabulous photographs.

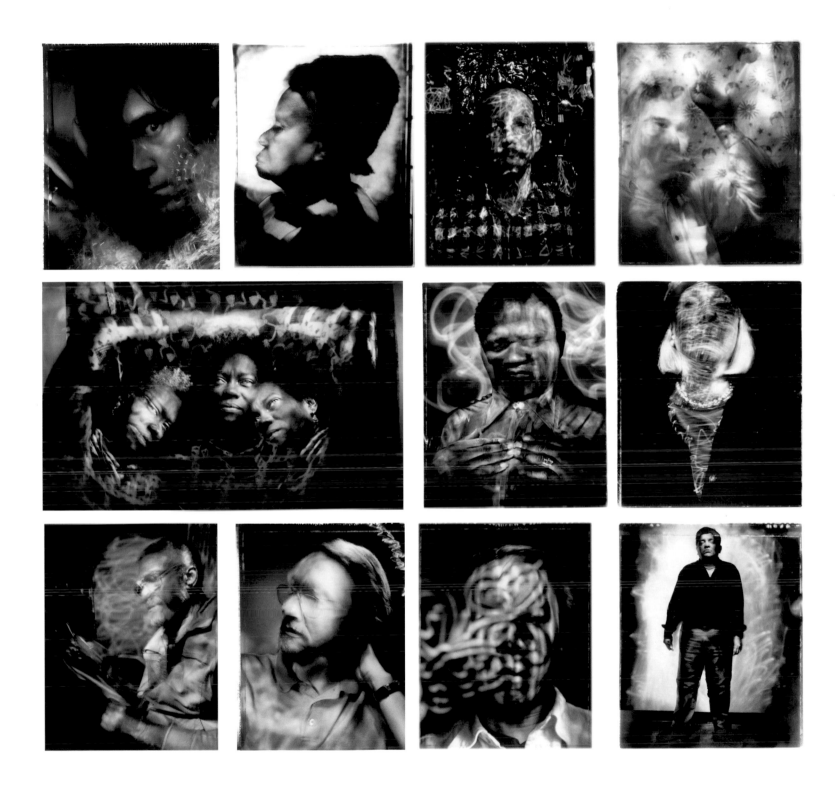

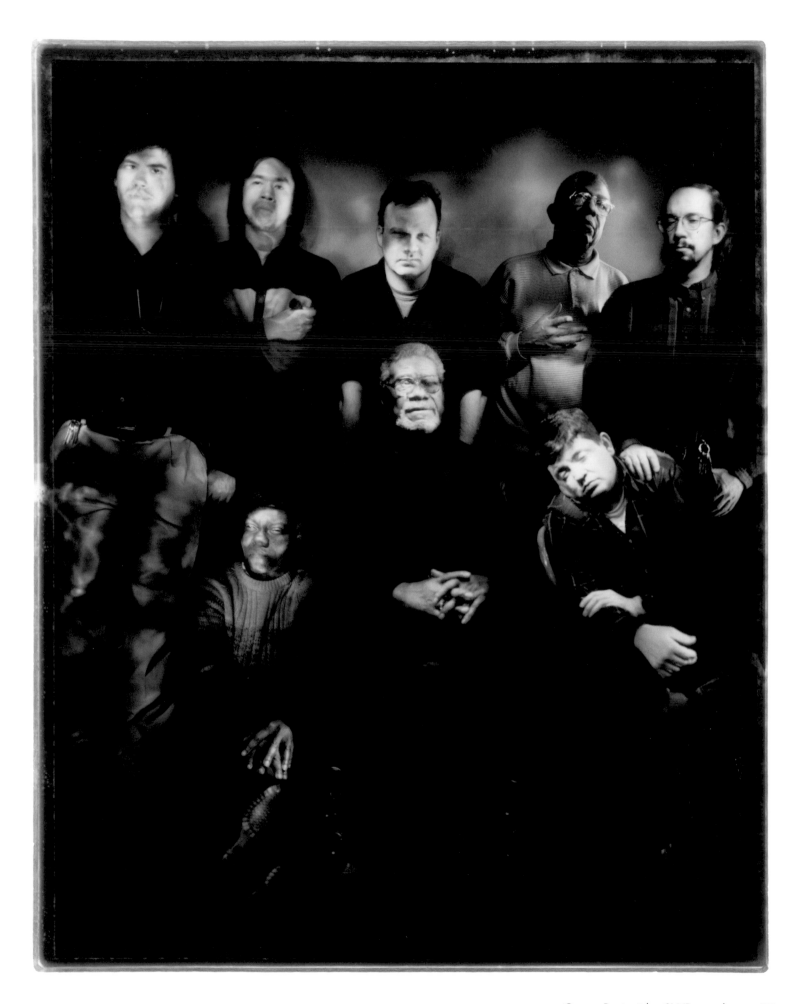

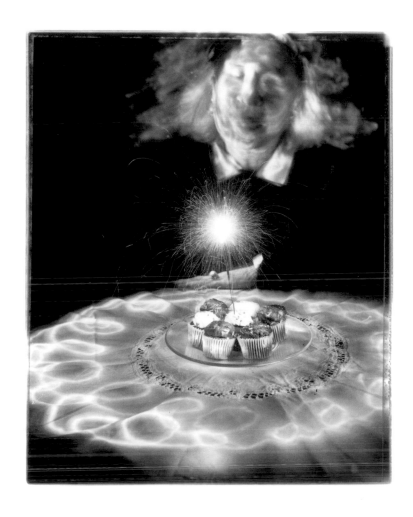

**In memory of Roseann Kahn 1924–2001
Her winning energy, adventurous spirit, and enthusiastic ideas
invigorated our work.**

THIS PUBLICATION IS GENEROUSLY SUPPORTED BY

THE ALBERT B. MILLETT MEMORIAL FUND TRUST

DOROTHY S. AND MYRON B. HOFFMAN

AND THE DUNN MARSH FAMILY, IN HONOR OF
TWO MEN OF EXTRAORDINARY VISION:
RICHARD J. DUNN AND MICHAEL E. HOFFMAN

Over the years there have been many more contributors to our work than those represented in this book. Other members of our program include Douglas Ford, Elizabeth Vasquez, Pat Ventriello, Fred Moy, Miriam Carter, and José Fernandez.

This body of work could not have been created without our generous and dedicated volunteers. Sally Bierman, Mary Walling Blackburn, Dale Cannedy, Kim Garrahan, Christina Hardy, and Karen Knobloch were truly helpful participants in the process.

I especially would like to thank Josette Paul, Ellie Winninger, Rebecca McGinnis, Paul Miller, Karen Johnson, and the Honors Photography students at the Horace Mann School. Modernage and Rehabilitation Through Photography have consistently donated supplies and services. Nancy Miller, Betsy Fabricant, Caroline Wolfe, and the rest of the staff at Visions provide a warm and caring home for our program.

This book is the culmination of many years of working together. Numerous people have come into the class and posed for a picture or manned a flashlight, sent a check or given supplies and equipment. Thanks to all.

My wife, Judith, and my children, Beryl, Avi, and Sasha, have made this endeavor a part of their lives as well.

Finally, thanks to the wonderful staff at Aperture. More than just publishers, they have been our true friends.

—Mark Andres, Program Director,
Seeing with Photography

Library of Congress Catalog Card Number: 2001088027
Hardcover ISBN: 0-89381-994-8

DESIGN BY MICHELLE DUNN MARSH

Separations by Bob Hennessey, Middletown, CT
Printed by Sing Cheong Printing Co., Ltd., Hong Kong

The Staff at Aperture for *Shooting Blind* is:
Michael E. Hoffman, Executive Director
Hiuwai Chu, Editor
Stevan A. Baron, V.P., Production
Lisa A. Farmer, Production Director
Andrew Hiller, Associate Editor
Bryonie Wise, Production Assistant
Mary Walling Blackburn, Editorial Assistant
Tanya Luna Bunnag, Editorial Work-Scholar
Ehren Seeland, Design Work-Scholar

Aperture Foundation publishes a periodical, books, and portfolios of fine photography and presents world-class exhibitions to communicate with serious photographers and creative people everywhere. A complete catalog is available upon request.

Aperture Customer Service: 20 East 23rd Street, New York, New York 10010. Phone: (212) 598-4205. Fax: (212) 598-4015. Toll-free: (800) 929-2323. E-mail: customerservice@aperture.org

Aperture Foundation, including Book Center and Burden Gallery: 20 East 23rd Street, New York, New York 10010. Phone: (212) 505-5555, ext. 300. Fax: (212) 979-7759. E-mail: info@aperture.org

Aperture Millerton Book Center: Route 22 North, Millerton, New York, 12546. Phone: (518) 789-9003.

Visit Aperture's website: www.aperture.org

Aperture Foundation books are distributed internationally through:

CANADA: General/Irwin Publishing Co., Ltd., 30 Lesmill Road, Don Mills, Ontario, M3B 2T6, Canada. Fax: (416) 445-5967.

UNITED KINGDOM, EIRE, SOUTH AFRICA: Aperture c/o Robert Hale, Ltd., Clerkenwell House, 45-47 Clerkenwell Green, London, United Kingdom, EC1R OHT. Fax: (44) 207-490-4958.

WESTERN EUROPE, SCANDINAVIA: Nilsson & Lamm, BV, Pampuslaan 212-214, P.O. Box 195, 1382 JS Weesp, Netherlands. Fax: (31) 29-441-5054.

AUSTRALIA: Tower Books Pty. Ltd., Unit 9/19 Rodborough Road, Frenchs Forest, Sydney, New South Wales, Australia. Fax: (61) 2-9975-5599.

NEW ZEALAND: Southern Publishers Group, 22 Burleigh Street, Grafton, Auckland, New Zealand. Fax: (64) 9-309-6170.

INDIA: TBI Publishers, 46, Housing Society, South Extension Part-I, New Delhi 110049, India. Fax: (91) 11-461-0576.

To subscribe to the periodical *Aperture* write Aperture, P.O. Box 3000, Denville, New Jersey 07834, or call toll-free: (866) 457-4603. One year: $40.00. Two years: $66.00. For international subscriptions call: (973) 627-2427. Add $10.00 per year.

FIRST EDITION
10 9 8 7 6 5 4 3 2 1